IMAGES
of America

LIGHTHOUSES AND LIFE SAVING ALONG CAPE COD

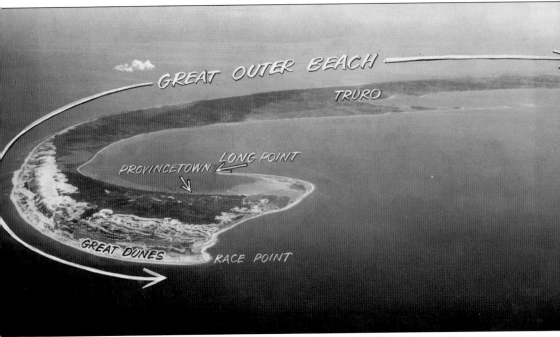

The Great Outer Beach of Cape Cod extends east and south from Race Point in Provincetown to Monomoy Point in Chatham. Beyond the shifting sandy beaches are numerous hidden sandbars. Hundreds of shipwrecks have occurred off these shores over the years, with great loss of life. This c. 1954 photograph shows the area from Provincetown to Wellfleet from 19,200 feet. (Photograph by Institute of Geographical Exploration at Harvard University; author's collection.)

ON THE COVER: A Life-Saving Service crew prepares to launch their surfboat toward a wreck. Cape Cod crews worked in all weather, overcoming all hardships to affect rescues, and over the years, the crews achieved an unprecedented record of lives saved. By the 1890s, the Cape Cod shipping lanes would be guarded by 13 life-saving stations, 21 lighthouses, and 10 lightship stations in an effort to prevent shipping tragedies. (Author's collection.)

IMAGES
of America

LIGHTHOUSES AND LIFE SAVING ALONG CAPE COD

James W. Claflin

ARCADIA
PUBLISHING

Published by Arcadia Publishing
Charleston, South Carolina

Printed in the United States of America

Library of Congress Control Number: 2013957854

For all general information, please contact Arcadia Publishing:
Telephone 843-853-2070
Fax 843-853-0044
E-mail sales@arcadiapublishing.com
For customer service and orders:
Toll-Free 1-888-313-2665

Visit us on the Internet at www.arcadiapublishing.com

*To all the men and women of the US Coast Guard who carry
on the traditions, and to my father, Kenrick A. Claflin*

CONTENTS

Acknowledgments 6

Introduction 7

1. The Early Years 9

2. The Outer Cape 15

3. Massachusetts Humane Society 59

4. The Lower Cape 63

5. US Life-Saving Service 79

6. The Mid-Cape 89

7. The Lightships 95

8. The Upper Cape 107

9. US Coast Guard 113

Bibliography 127

ACKNOWLEDGMENTS

Although the majority of the photographs and images used in this volume are from my own collection, I could not have put this book together without the kind and able assistance of a number of individuals.

First, thanks should go especially to my dad, Kenrick A. Claflin, who passed on to me a love and appreciation of history, his integrity, and the love of all things maritime and antique.

Thanks should go to Andy and Anita Price, maritime antique dealers and fine artists, for their friendship, encouragement, and willingness to answer my many questions over the years.

Also thanks to Ralph and Lisa Shanks for their continued encouragement and support over the years; to Frederic L. Thompson, author of *The Lightships of Cape Cod*; and to lighthouse and Life-Saving Service experts Richard Boonisar and Jeff Shook. Additional thanks to Life-Saving Service small-boat historian Cmdr. Timothy R. Dring of the US Navy Reserve (retired) for his willingness to help whenever I ask and for the use of some of his station photographs.

I also wish to thank my editor at Arcadia Publishing, Caitrin Cunningham, and the Arcadia staff for their guidance on this and other volumes over the years.

My sincere appreciation to you all. You were most kind and generous, and you took the time when I asked. I also would like to express my sincere gratitude to all of the lighthouse keepers, lifesavers, Coast Guard personnel, and their families, both living and past. You all have performed your duty well and set the standard for the future.

And, finally, thanks to Margie.

Unless otherwise noted, all images appear courtesy of the author and Kenrick A. Claflin & Son Lighthouse Antiques.

INTRODUCTION

Arthur W. Tarbell wrote of outer Cape Cod in 1934: "From Monomoy Lighthouse in Chatham to Long Point Light at Provincetown . . . from the elbow of the Cape to the tip of its slender forefinger, this long shore arches out like a huge crescent into the Atlantic."

By 1914, there would be 203 life-saving stations dotting the coastline of the United States, 13 of them on Cape Cod, but in the mid-18th century, there were none. And there were only a handful of lighthouses in the country in the 1770s as well.

New Englanders have always been heavily dependent on the sea for their employment, commerce, and nourishment. By the 1800s, with thousands of vessels plying the dangerous waters of Massachusetts Bay, around Cape Cod, and through Nantucket Sound, the chance of a shipping disaster was always great. Hundreds of shipwrecks did indeed occur off the Massachusetts coast, with startling losses.

During the colonial years, each of the 13 colonies established a handful of lighthouses and other navigational aids according to their needs. The first lighthouse in the colonies was lit in Boston Harbor on Little Brewster Island in 1716. As time went on, the need for more beacons was realized, and additional lights were established on Brant Point on Nantucket in 1746, in Plymouth on Gurnet Point in 1769, and on Thatcher Island off Cape Ann in 1771. By 1792, as traffic around Cape Cod continued to increase, mariners began to petition for a sorely needed lighthouse on Cape Cod.

As commerce increased and shipwrecks and attendant loss of life became more frequent, the newly formed federal government realized that a more coordinated system of lights and navigational aids was needed. Thus, in 1789, Congress acted to place the responsibility for all navigational aids under the federal government. Unfortunately, during this period, economy of operation ruled over efficiency, causing the lighthouses of the United States to become some of the poorest-quality in the world. Many concerns were voiced until the new Light-House Establishment was formed in the 1850s under one administrative board. Thus began a new era, one of high quality and efficiency that continued through the 1930s, when the Coast Guard assumed responsibility.

At about the same time, the citizens of Massachusetts were becoming more concerned about the incidents of shipwreck and loss of life along the coast. Although a coordinated system of lighthouses and lightships helped many a mariner find his way clear of treacherous shoals and sandbars, the occasional shipwreck did inevitably occur as the fog and fierce New England storms forced ships ashore, causing repeated loss of life. Sometimes, shipwrecked sailors were able to make their way ashore only to perish on desolate beaches from lack of shelter. Prominent citizens of the day began to appreciate the need for a system of shelters and rescue for mariners driven ashore, and in 1785, an organization to be called the Massachusetts Humane Society was founded. Many notables of the time, including Paul Revere and John Hancock, were listed on the rosters of the society, and there began what would become the foundation of the American system of rescue from shipwreck. Based on the British model, the Massachusetts Humane Society began to

establish huts along the shores to provide shelter to those in need. On Lovell's Island in Boston Harbor, the first "house of refuge" was established, with many more to follow. By 1807, the first lifeboat station would be established by the Massachusetts Humane Society and provided with a first-class, 30-foot whaleboat manned by 10 volunteers. Many rescues were performed using this boat, and the die was cast. By the 1870s, the Massachusetts system had grown to over 70 stations. But just as with the lighthouses, a still-more efficient and coordinated system was needed as maritime trade continued to expand.

After a number of spectacular shipwrecks and fatalities, Congress finally in 1871 appropriated funds to create a coordinated system of life saving along the coast, and by the late 1870s, Sumner Increase Kimball would take over as its superintendent. The service became the US Life-Saving Service, and by the next decade, Kimball had created a model service that would last for 45 years and would boast an unprecedented record of rescues, service, and organization.

In 1915, the US Life-Saving Service would be merged with the US Revenue Cutter Service and continue its fine record as the United States Coast Guard.

Though many of the early lighthouses and life-saving stations no longer exist, and their crews have long since retired, their stories and documentation of their achievements remain forever in official records and in the many photographs that have been saved. These remote locations were more than just job sites; they were home to the men and their families. Indeed, many of the families played vital rolls in maintaining the lights when the keepers were caught away during storms. The wonderful photographs that remain today offer a glimpse into the everyday lives of the dedicated men and women of these government services.

The light stations and Coast Guard stations along the New England coast today are reminders of a seemingly simpler time and of a fabric of historic significance. We long to remember the ways of the men and women who tended the lighthouses, lightships, and buoys and patrolled the beaches. Devoted to their duty, they were heroes to many as they kept their long, lonely vigils.

Cruising by the lighthouse on Race Point or those at Wood End and Long Point, it is easy to feel a sense of what life was like a century ago. Through the years, little has changed—seafaring still comes down to one's own ability pitted against the elements. As you sit down to turn these pages, think of the Race Point keeper in his Lighthouse Service uniform proudly cleaning the lens, of the Monomoy lifesavers launching their surfboat into the breakers toward a wreck, or of the Billingsgate keeper as he returns by skiff with his family from a brief excursion to Wellfleet for supplies. Think, too, of the lives they lived, the standards of excellence they set, and their devotion to duty. And enjoy the voyage.

> We remember the brave men—seamen—who launched their dory . . . who periled their lives to save men who were clinging to the rigging of a wreck . . . when landsmen who were looking on could only wring their hands and pray, these men who know no danger dash through the surf in their "skimming shell" boat, on to the rescue, every nerve straining at the ashen oar, with an eye on every billow and comber, pulling, bailing, praying, until they reach the wreck and save the living men. Then amid the shouts that outrival the thundering of the sea, the roaring of the no'th-easter, they land these perishing men, and the congratulations of the crowd are showered upon them. All hail to these acts of bravery.
>
> —Capt. Sylvester S. Nickerson, May 1890

One

THE EARLY YEARS

The history of the Light-House Establishment and life-saving services in the United States spans over 250 years. In the early years, before the American Revolution and the organization of a centralized federal government, the services provided were haphazard at best. The few lights for navigation that existed might be installed by a group of sea captains realizing the need but finding no organization charged with the responsibility. The light established by local subscription in an attic window at Bass River in Dennis is a good example of the temporary solutions instituted by the maritime community. As time went on, the Commonwealth of Massachusetts, when put under sufficient pressure from shipowners and merchants, began to establish some beacons in strategic locations in the 1700s. However, by the early 1800s, it was becoming apparent that the system of lights in the country was wholly inadequate and greatly inferior to those of most other maritime nations at the time.

In the United States, what few lighthouses did exist were poorly constructed and minimally maintained. Compounding the problem was the system of political patronage prevailing at the time. In the early 1800s, the president of the United States and the secretary of the treasury made the appointments of lighthouse keepers based on the local recommendations of influential public officials. Following presidential elections, if the political party in the White House changed, then so too did the secretary of the treasury and many of the light keepers as well. Reading the records of the early years often reveals keepers serving only a few years, being replaced following an election, and sometimes returning later when their political party was back in office. The overall effect was that the lighthouses were often manned by poorly trained, unskilled persons, if manned at all. Many light keepers, as well as shipmasters, soon became disgruntled with the system. Occasionally, a sea captain would approach a landfall only to find the light emitted from the lighthouse to be of very poor quality, or the lighthouse even unlit or abandoned.

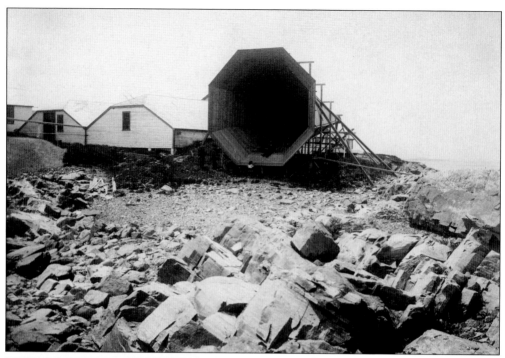

By 1840, Congress had begun to recognize the importance of an organized system of navigation to the growing maritime nation and soon began to enlist a number of engineers to study the existing system and make recommendations. In 1852, a comprehensive 760-page report was issued, with one of its primary recommendations being the appointment of an independent Light-House Board to organize and coordinate the nation's system of aids. Shown is an experimental fog signal at Boston Light Station.

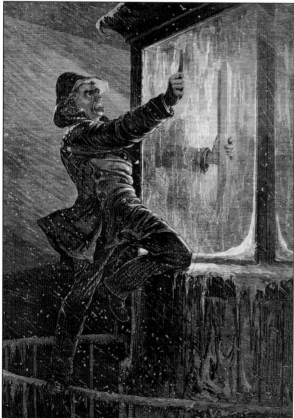

With the adoption of the Light-House Board, a system of order was finally brought to the lighthouses and navigational aids in the country. Many new lighthouses, beacons, and buoys were constructed, and maintenance was improved on existing stations. New fog signals and light vessels were added, and many new programs were instituted to study and improve the equipment in use.

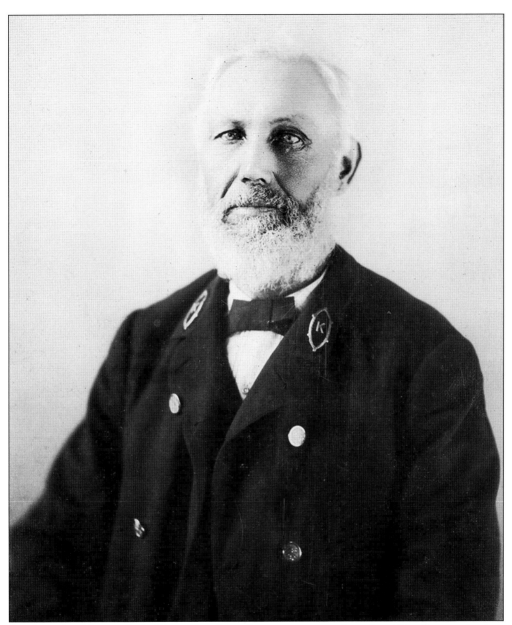

One benefit of the new Light-House Board was the improvement of morale within the organization. Experience and ability now became a determining factor in keeper appointments. As the working conditions improved, so too did the keepers' lives, and many keepers began long careers. From this point on, lighthouse keeper became an important and respected position, with many keepers and their families serving up to 50 years. With these new regulations too came strict attention to detail. Rules now existed requiring keepers to be neatly and completely uniformed, and inspections were made by the district inspector to ensure that the station was in good order. Now, the keepers were happy to be part of the organization, and they wore their uniforms proudly and with dignity, as many early photographs of the day suggest. Note the "K" on this keeper's collar, indicating that he is the principal keeper rather than one of the assistant keepers. This is Stephen Lewis, who served at Eastham's Nauset Lights from 1883 until 1914.

The earliest lights along the coast consisted of crude towers supporting a wood or pitch-fed flame, and later, candles. By the 1820s, the federal government began using lamps fueled by whale oil with a glass magnifying lens designed by Winslow Lewis. By the 1850s, with the advent of improved glass optics invented by Augustin Fresnel, the Light-House Board began to refit American lighthouses with the more powerful Fresnel arrangement.

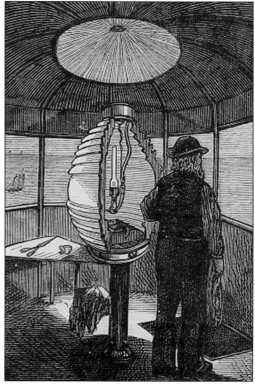

By the 1850s, the Light-House Board began to experiment with new methods of lighting, new lamps, and different types of oil and fuel. One of the most important advancements adopted by the new board was an invention by Frenchman Augustin Fresnel that concentrated lost rays of light from the oil lamps into a powerful horizontal beam. This new Fresnel lens of glass prisms would completely revolutionize the Light-House Establishment.

The Instructions to Keepers in 1902 noted, "All keepers at light stations shall wear a uniform in accordance with the uniform regulations issued by the Board. The utmost neatness of buildings and premises is demanded. Lights must be lighted punctually at sunset, and must be kept burning at full intensity until sunrise. The lens and the glass of the lantern must be cleaned daily and always kept in the best possible condition."

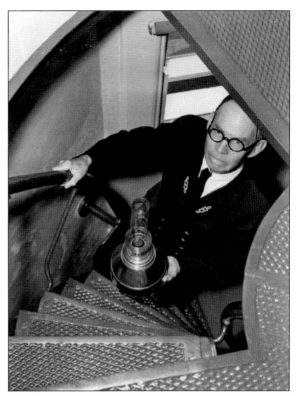

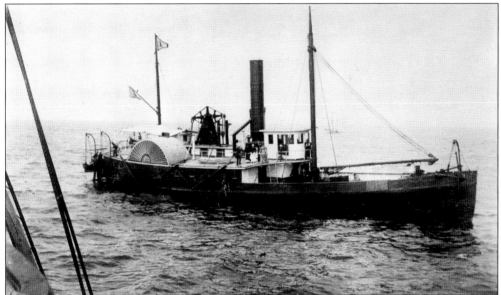

The Light-House Board organized the country into 16 districts, each with depots to service and supply the lighthouses. Massachusetts was in the second district, and the depots included Chelsea, Cohasset, Lovell's Island, Wood's Hole, and New Bedford. From these depots, lighthouse tenders would service the light stations and lightships and perform buoy and other maintenance. The lighthouse tenders were named for flowers and included the *Iris*, the *Myrtle*, the *Verbena*, the *Cactus*, and the *Holly*.

As time went on, the US lighthouse system would continue to improve. In 1903, the Light-House Board was transferred to the Department of Commerce and Labor, and in 1910, the Light-House Board was officially terminated. The governing body officially became known as the Bureau of Light-Houses. George R. Putnam was appointed commissioner of lighthouses, and he would continue to improve technology and equipment to keep pace in the 20th century. During Putnam's tenure, all facets of aids to navigation were examined and improved. New fuels, including acetylene for use on lighted buoys, such as this one, were added, and electricity would later replace oil for lighting most lighthouses. Fog signals were tested and improved, and the old bells were replaced with steam- and air-powered diaphone horns. In addition, Commissioner Putnam's technicians developed the new radio technology for use in ships to determine their positions at sea. In 1939, the Bureau of Light-Houses was eliminated, and the operation of the nation's aids to navigation was consolidated yet again, this time into the US Coast Guard, under whose authority they remain today.

Two

THE OUTER CAPE

Cape Cod has been known the world over for its fine, sandy beaches and beautiful, starlit skies. The area abounds with schools of fish swimming in its outer reaches, flocks of nesting shorebirds, seals, and numerous other wildlife species. People from the world over travel to Cape Cod to enjoy its quite solitude and unspoiled beauty. However, only the sailor knows of its deep darkness and driving gales, its mounds of ice and drifting snow, and the perils imposed by its shifting outer bars.

Henry C. Kittredge wrote in 1930, "It has been said that if all the wrecks which have piled up on the back side of the Cape were placed bow to stern, they would make a continuous wall from Chatham to Provincetown. This is a picturesque way of putting what is substantially the truth, for Peaked Hill Bars and the Monomoy Shoals are to sailors of to-day what Scylla and Charybdis were to Aeneas. Nauset Beach, which stretches along the whole coast line of Orleans and Eastham, holds in its fatal sands the shattered skeletons of vessels from half the seaports of the world; while farther north, the outer shores of Wellfleet and Truro have gathered in the hulls of a thousand ships, driven helplessly upon them by northeast gales. Even the comparatively sheltered waters of the Bay have had their share of shipwrecks." Still, settlements were established, and seafaring became a way of life on the outer Cape.

One such settlement began in 1818, and by the 1850s, a thriving village had been erected on the sandy shoal protecting Provincetown Harbor, known as Long Point. Included among the more than 200 inhabitants of this growing village were fishermen and those who worked in other necessary trades, including salt works and the attendant windmills to pump the seawater. By the 1860s, two forts were built at Long Point, close to the lighthouse, to protect the area from blockade runners during the Civil War, but they would never see action. Nicknamed "Fort Useless" and "Fort Harmless" by the locals, the only action that they ever saw was at the yearly Fourth of July celebrations.

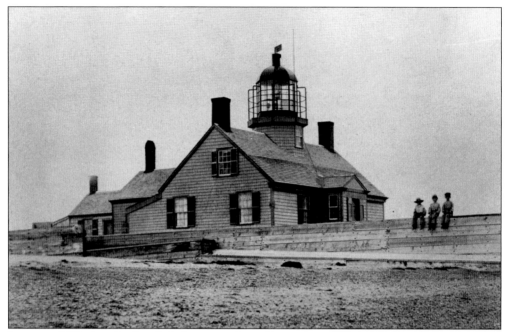

It was in 1822 that the first lighthouse on Long Point was constructed. It took some time to complete work on the light, and it was finally finished in 1826. The light consisted of a lantern on the roof of the keeper's house with a fixed light positioned 35 feet high and visible for 13 nautical miles. The wooden dwelling was erected on wood piles driven into the sand.

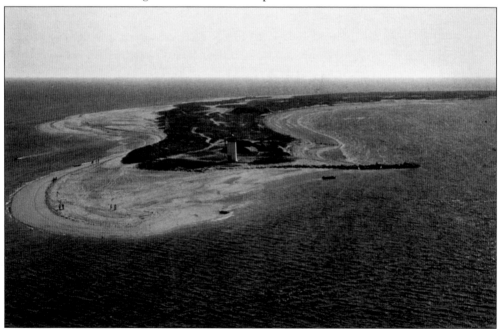

The first keeper was Charles Derby. In the 1830s, a school for Long Point children was operated at the lighthouse, with 60 students attending. By 1843, Charles Derby was still keeper. He complained to the inspector that, while he had a boat, there was no boathouse or landing place and that he had lost a boat the previous year due to the lack of a proper slip. (Cape Cod Photos.)

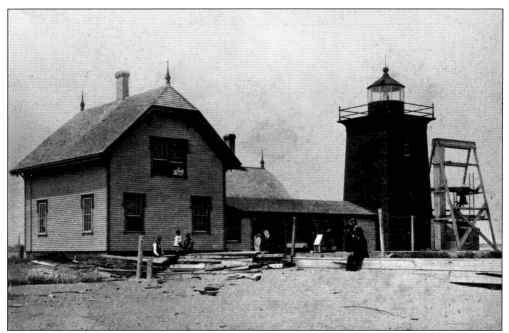

A number of other early lights on Cape Cod would be built in this Cape Cod style, including the Pamet River and Mayo's Beach lights. The second lighthouse was constructed in 1873–1874 to replace the aging structure and included a new dwelling with clipped-gable roof and a fog-bell tower. The new, 38-foot, brick lighthouse was square and was painted brown for visibility.

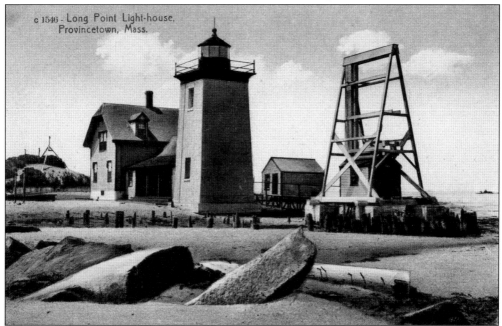

The 1.5-story keeper's house was also built in 1875, and a 1,200-pound fog bell was installed at that time. The lantern held a fifth-order Fresnel lens showing a fixed white light. By 1900, it was determined that the brown light tower was difficult to see against the background of Provincetown, and the light tower was painted white for better visibility. An oil house was added in 1904.

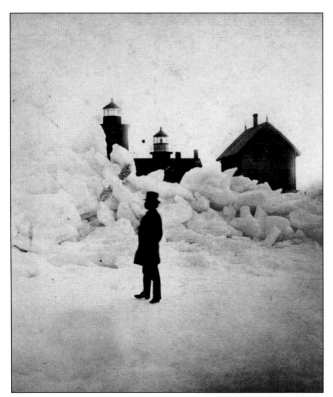

The winter of 1875 on Cape Cod was unusually cold, with terrible ice trapping many vessels. Many stranded sailors sought refuge in the light keeper's dwelling. As the waves pounded the shore, huge mounds of ice built up, blocking the beacons and lasting from January until March. At left, a gentleman climbs the ice at Long Point. Note that the old 1826 light tower still remains. (Photograph by Nickerson.)

Shown is a typical Fresnel lens in use by the 1880s. Lens apparatus was classified in seven orders or sizes, the first order being the largest and most powerful and standing about 12 feet tall. The oil-burning lamp would be in the lens center. Lighthouse lamps had one or more circular wicks for more-efficient burning and were manufactured at the Light-House Depot on Staten Island, New York.

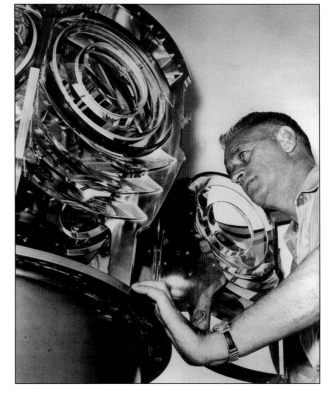

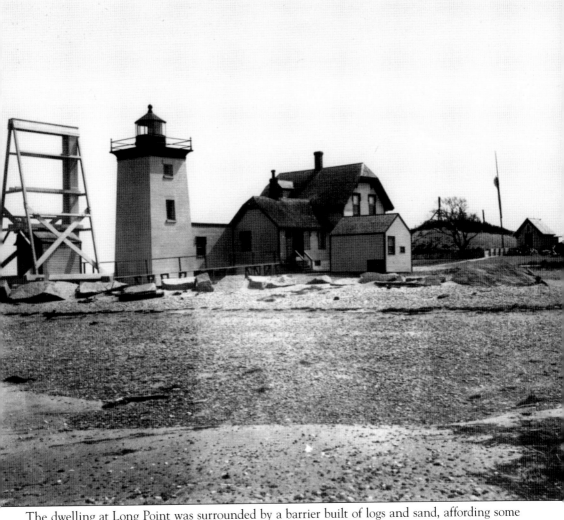

The dwelling at Long Point was surrounded by a barrier built of logs and sand, affording some protection from the surf. Note the tall fog-bell tower on the left; to the right, a Civil War–era fort can be seen. In 1933, during a thick fog, the mechanism that rang the fog bell broke down. Keeper Thomas L. Chase rang the bell by hand for over nine hours, pulling the rope with his right hand every 30 seconds. After a few hours of sleep, he had to sound the bell for several more hours. The lighthouse was automated in 1952, and the Coast Guard personnel were removed. The lens was replaced by a modern optic, and in 1982, solar panels were installed. The keeper's house was removed in the 1980s, but Long Point Light remains an active aid to navigation today.

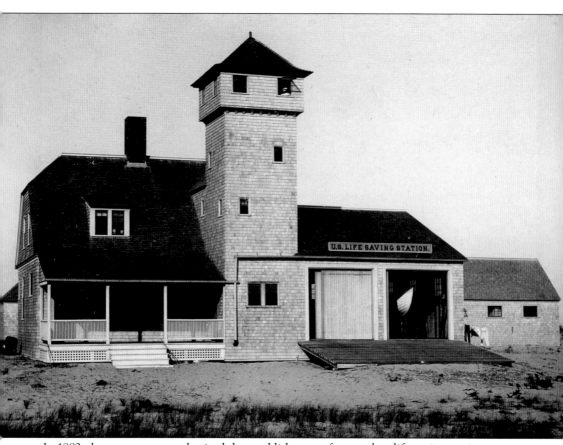

In 1882, the government authorized the establishment of a complete life-saving station at or near Wood End. The Wood End Life-Saving Station was built on the "hook" of Cape Cod in 1896, one-eighth mile east of Wood End Light and was manned with a keeper and six surfmen. When not cleaning or at drills, the surfmen often spoke with visitors, posing for their cameras, or spent time caring for their pets. Many stations had a dog or cat for company during the long watches. The station cat here was named Tom, and he often accompanied the men on patrol. Tom knew every foot of the beach and often led the way. Horses, too, were found at some stations to aid in pulling the heavy apparatus through the soft sand. However, the government, in its frugality, rarely provided horses, so personal mounts would often be used. At Wood End, the horse Jim was owned by Keeper Bickers and often aided the crew. (Photograph by L.M. Snow.)

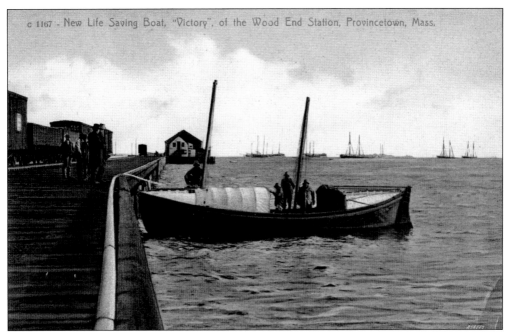

The station was somewhat improved in 1910, probably to give it the capability to operate the new motorized lifeboat. The station was still listed in 1945, but it disappears from the listing of stations in October 1948. By the late 1950s, the property was deemed excess and was sold to American Legion Post 23. It is not recorded how much longer the station remained before being demolished.

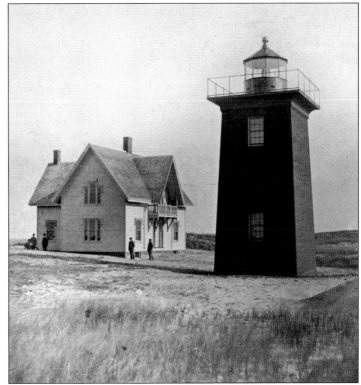

Wood End Light is a square, white tower on the extreme southern point between Long Point and Race Point lights. The light's 11,000-candlepower, red beacon illuminates the sea for 12 miles around. The brick light tower, originally painted brown, was built in 1873 and was identical to that at Long Point, making identification difficult at times. More than 50 shipping disasters occurred at Wood End between 1873 and the 1940s.

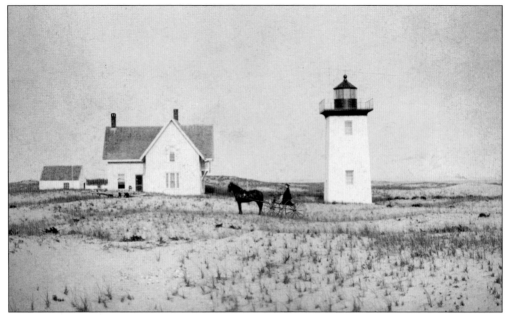

In Henry David Thoreau's book *Cape Cod*, he describes a shipwreck at Wood End during a mist when, after striking the sandbar, the rigging was washed over by the sea and the passengers nearly drowned. As Thoreau passed through Wood End on his walk, he noticed a pile of lumber, which had been the vessel's deck cargo, washed ashore. (Photograph by M.W. Smith.)

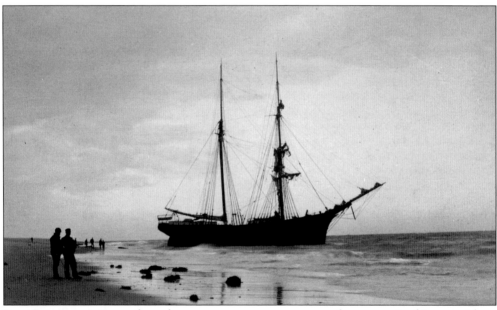

Race Point gets its name from the strong crosscurrent, or race, that occurs in this area. Along the ocean side lie great stretches of treacherous sandbars covered by the tides. After hundreds of shipwrecks over the years, in 1808, local residents, merchants, and captains alike finally requested that the government build a lighthouse to help ships navigate around the hazardous race currents on their way to the Atlantic or to Provincetown Harbor. (Photograph by M.W. Smith.)

By 1816, an appropriation was made to build a lighthouse at Race Point. This would be only the third lighthouse built on Cape Cod—coming after Highland Light and the twin lights at Chatham—and would be the first of three lighthouses to be constructed in Provincetown. A rubble-stone tower with a revolving light, 25 feet above sea level, was built on the site, along with a one-story, stone keeper's dwelling.

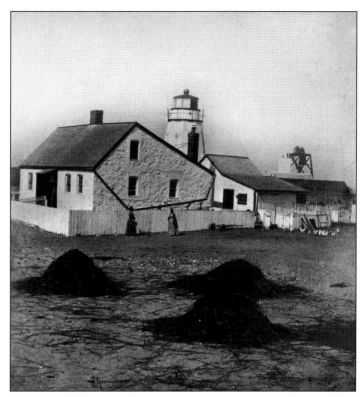

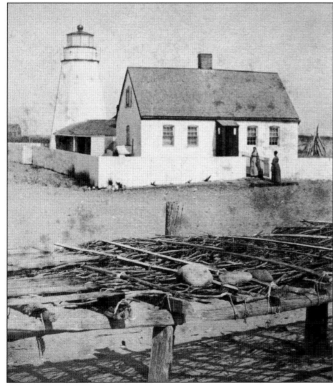

From about 1800 and over the next few decades, a sizeable fishing village and salt works, called "Helltown" by the local inhabitants, was established at Herring Cove, a short distance east of Race Point. The little community grew and was soon declared a separate school district in the 1830s. Salvagers from the community supplemented their earnings by collecting and selling the remains of shipwrecks found on the beaches around Race Point.

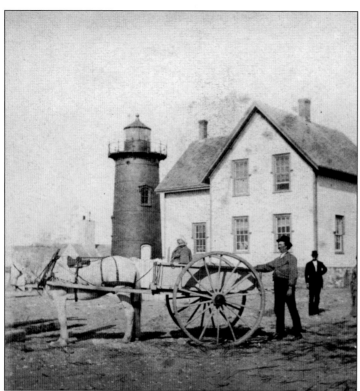

In 1875, the original lime mortar in the tower had finally deteriorated to the point that it had disappeared, and the interior was rotten. In 1876, the stone light tower was torn down, and a new, 40-foot tower was constructed of the latest design—cast-iron sheets bolted together and lined with brick. Also, in 1876, a new keeper's house was built to house the principal keeper and his family.

During the 1930s, Lighthouse Service inspectors reported that the station was immaculately kept, though the keepers did have their difficulties. In one report, the keepers noted that they were "hopelessly afloat in a sea of mosquitoes." Over the years, fishermen had reported mosquitoes blown as far as 70 miles out to sea. This must have been a common dilemma of the time, and one wonders how the families persisted. (Photograph by J.L. Rosenthal.)

F.F. Haskell, keeper of the Race Point Light Station, poses in 1944 on the tower stairway leading up to the lantern. Haskell's predecessor, James Hinckley, solved the problem of long trips into town for groceries when, in 1935, he specially modified his car with balloon tires to make the trek in half the time. Keeper Hinckley retired in 1937 on his 70th birthday. (Photograph by Edward Rowe Snow.)

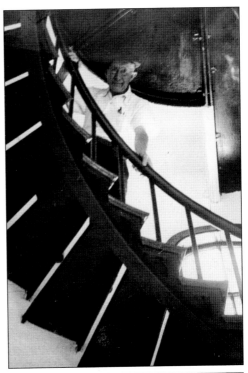

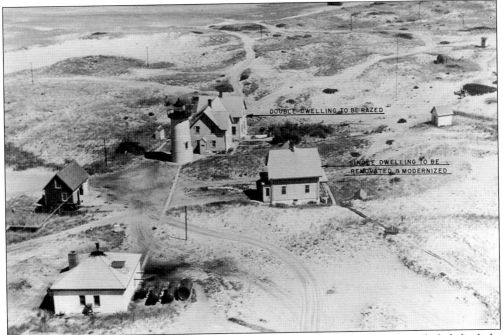

During the Coast Guard era, from 1939–1972, the Race Point Light Station included the light tower, two dwellings, fog-signal building, oil house, stable or garage, and other utility structures. In 1961, the two-family assistant keepers' dwelling nearest the light tower was no longer needed and was demolished. The remaining principal keeper's dwelling was modernized at a cost of $20,000 for use by the Coast Guard keeper and his family.

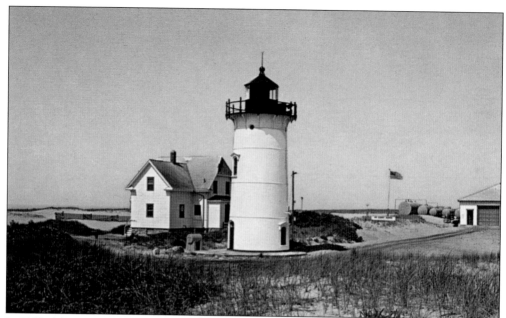

In 1957, electricity was provided to the station, and the lamp was changed from kerosene oil vapor to an electric 1,000-watt bulb. This development increased both the power and range of the light. On August 7, 1961, Race Point light became a part of the Cape Cod National Seashore. Though still under Coast Guard control for operation and maintenance, the area was now preserved for future generations. (Photograph by Yankee Colour.)

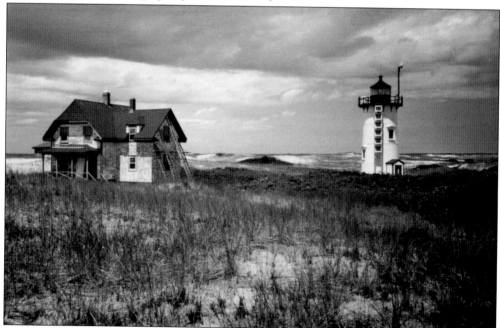

In 1972, Race Point light was automated, and it was no longer necessary to have a keeper on site. By the 1990s, solar panels were added for power. The keeper's house was abandoned by the Coast Guard and was all but forgotten following the automation. It remained closed and neglected for almost 20 years until 1995, when the site would be leased to the New England Lighthouse Foundation.

In 1995, Race Point Light Station, including the keeper's house, whistle house, and oil house, was leased to the Cape Cod chapter of the American Lighthouse Foundation with the intention of restoring the site and providing an overnight experience for visitors. Volunteers, including Jim Walker, Bill Collette Jr., Sidney Bamford, Scott Branco, and many others, worked countless hours to restore and rebuild the station, which is now enjoyed by many.

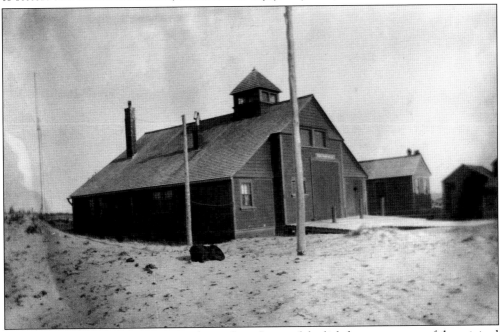

The life-saving station at Race Point, located northeast of the lighthouse, was one of the original nine erected on the outer Cape in 1872–1873. The coast at Race Point is very treacherous and had been the scene of many wrecks caused by the tides. There have been more than 90 major shipwrecks in the area since 1873, with over 600 lives saved by the men of the stations there.

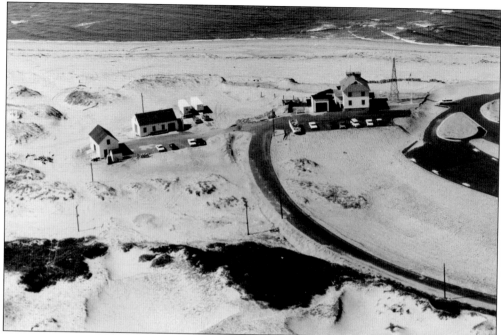

In 1930, a new building was completed at Race Point. However, the location became increasingly unsuitable. Modern rescue boats had to be tied up 2.3 miles away in Provincetown Harbor. About 1962, Coast Guard officials began to consider a replacement for Race Point station, and a new one was built in Provincetown's West End in 1978.

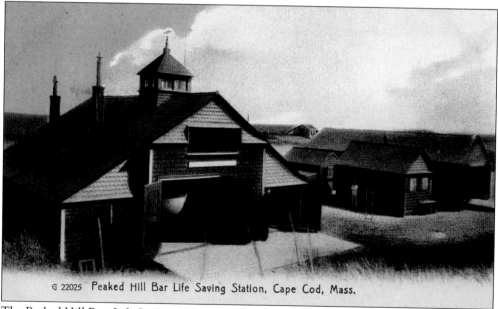

G 22025 Peaked Hill Bar Life Saving Station, Cape Cod, Mass.

The Peaked Hill Bars Life-Saving Station guarded the coastline where two sinister offshore bars wait to tear the bottom from unsuspecting vessels as they pass. Many ships have navigated the treacherous Race Point only to wreck upon the shifting Peaked Hill Bars. Because of the numerous wrecks here, the government erected a life-saving station at the spot in 1872 and manned it with a keeper and seven surfmen.

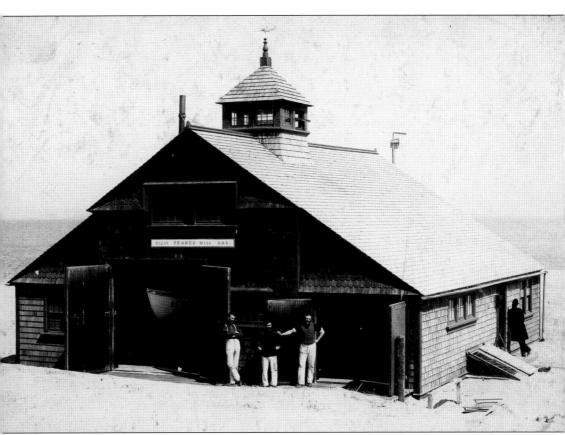

Many persons were taken ashore by surfboat by Captain Cook and his crew here at Peaked Hill station, including eight from the schooner *Willie H. Higgins* during the March 1898 blizzard. But on a November morning in 1880, the station would suffer a terrible loss. While attempting to assist the sloop *C.E. Trumbull*, which was stranded on the outer bar in a violent gale, Keeper Atkins and his crew launched their surfboat to assist. After a long pull through mountainous waves, the crew reached the wreck and brought four seamen ashore, then returned for those remaining. As they neared the wreck again, debris caught the surfboat and threw it over. The boat was righted, but it capsized again. As the surf pounded, the crew then fought to right the boat, only to have it capsize once again. Exhausted and unable to right it a third time, Keeper Atkins and Surfmen Elisha M. Taylor and Stephen F. Mayo slowly succumbed to the sea.

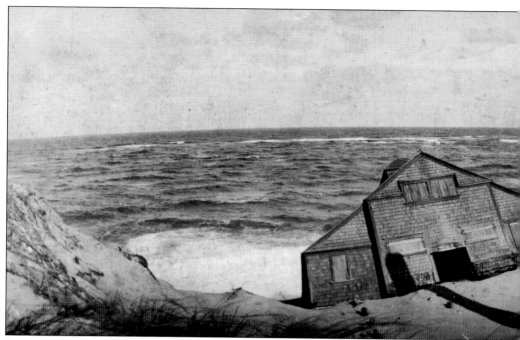

Soon, the dunes had built up to the point that the crews could not access the beach, so by 1910, a new station was constructed to the south. The building was sold to playwright Eugene O'Neill, who spent many years writing in the quiet solitude of the outer beach. In 1931, a strong storm raced up the coast, washing out hundreds of yards of beach and destroying the foundations under

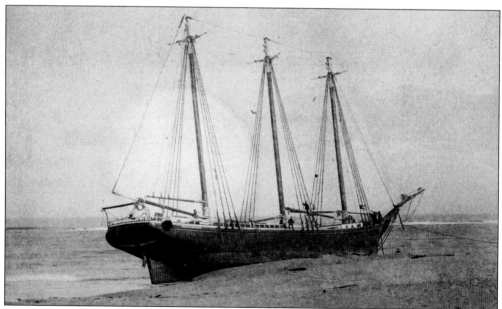

On December 20, 1884, the east patrol from the Peaked Hill Bars station discovered the *Panchita*, a three-masted schooner, ashore. The surf was running high, and snow and bitter cold were hampering the crew. But soon, the breeches buoy was in operation, and the second mate was landed. This photograph shows the *Panchita* on the sand the following day. (Photograph by W.M. Smith.)

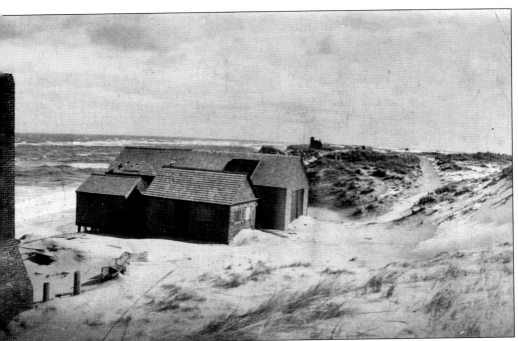

the old station. As residents watched, the building was washed into the sea. The new 1910 station saw many rescues as well. But by now, the advances in navigation and weather forecasting and the invention of radio were all making the sea-lanes safer. Over time, the incidents of shipwrecks would drop, and many of these stations would no longer be required.

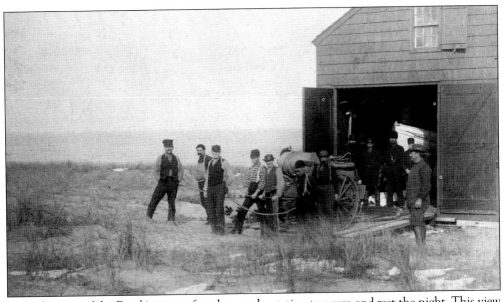

Soon the crew of the *Panchita* was safe, taken to the station to warm and rest the night. This view of the life-saving station was taken on the day following the wreck. Shown are Captain Fisher and his life-saving crew, seen behind the beach cart, along with members of the *Panchita's* crew rescued the previous day. The vessel was later saved with the aid of wreckers and a tug from Boston. (Photograph by W.M. Smith.)

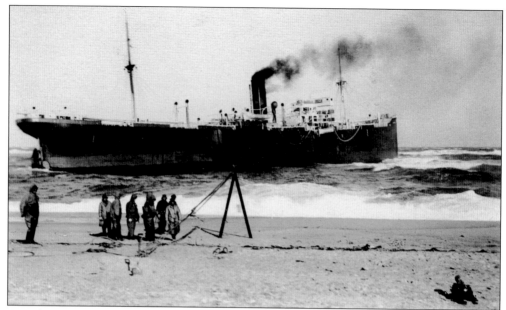

On February 7, 1922, the British freighter *Thistlemore* grounded on Peaked Hill Bars while fighting a northeast gale. The crippled freighter had on board a crew of 44 men in want of rescue, and Captain Gracie of the Peaked Hill Bars Coast Guard Station was quickly on the scene. The breeches buoy apparatus was assembled, a line fired to the vessel, and soon, 25 men were safely landed.

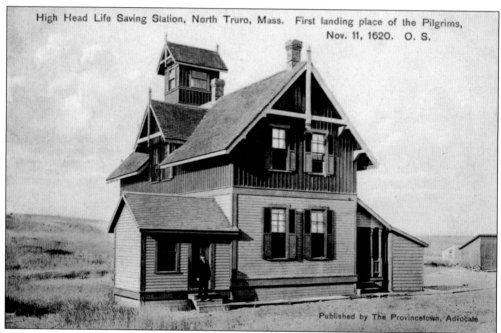

High Head Life Saving Station, North Truro, Mass. First landing place of the Pilgrims, Nov. 11, 1620. O. S.

Published by The Provincetown, Advocate

High Head Life-Saving Station was located about three miles north of Cape Cod Lighthouse in North Truro. The design was an interesting 1882 type of which only two others were constructed in Massachusetts. Keeper Charles P. Kelly, shown standing in the doorway, served an illustrious career in the Life-Saving Service, spending over 20 years as keeper at High Head, and was credited with rescuing over 40 persons. (Photograph by W.M. Smith.)

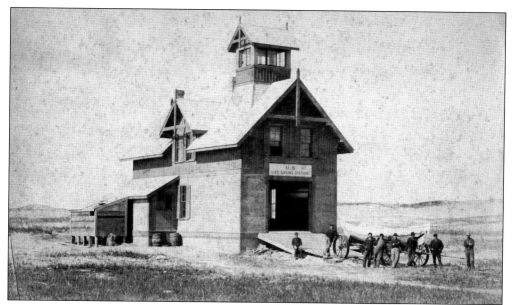

Note in this early photograph the life-saving crew posing with their surfboat. It is likely that Keeper Kelly is seen in this view as well. Kelly gained his surfman experience at the Peaked Hill Bars station and was one of the survivors of the accident in which three of that crew died trying to rescue the crew of the sloop C.M. *Trumbull*. (Photograph by W.M. Smith.)

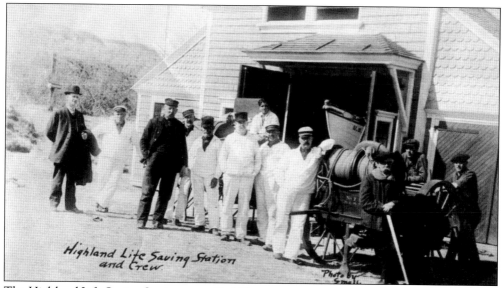

Highland Life Saving Station and Crew.

Photo by Smalli

The Highland Life-Saving Station was a Red House–type station, erected just three-fourths of a mile north of Cape Cod Light. It was typical of the nine stations on the outer Cape in 1872. The stations were sparse, divided into five rooms: an eating and sitting room, kitchen, keeper's room, boat and apparatus room, and second-floor sleeping quarters. On every station was a watchtower manned by day during good weather.

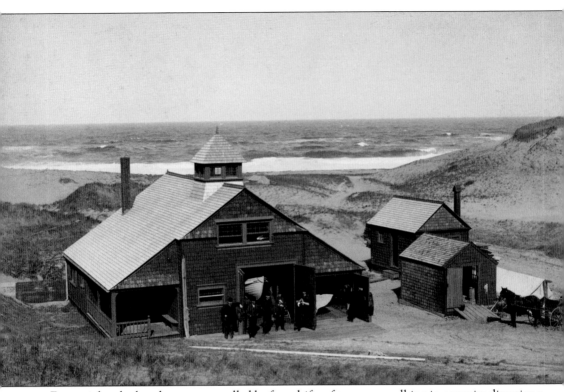

Every night, the beaches were patrolled by four shifts of two men walking in opposite directions. Each patrolman would go to the limit of the patrol area, usually two to four miles. They would meet with the surfman patrolling from the adjoining station, then return. Stations were manned from August until the following June, the busiest months, with the keeper remaining the full year. Stations were typically painted dark red so that they would be recognizable from the sea. In 1888, the Highland station was expanded, with the wings seen here built to house additional boats. The first keeper was Edwin P. Worthen, appointed in 1872 at the age of 36, with 13 years experience as a surfman. He served for 34 years but resigned due to physical reasons in 1907 at age 71. He was the oldest keeper in the service at that time. (Photograph by W.M. Smith.)

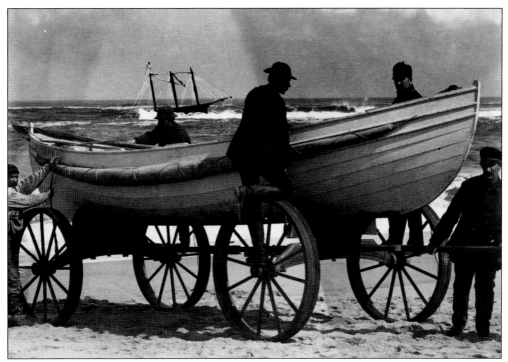

Boats used by the Life-Saving Service were specially constructed of cedar with white oak frames and were referred to as "surfboats" rather than the more common "lifeboat." The boats had air chambers at each end for flotation and were fitted with cork fenders to protect them during collision with a wreck. The surfboat was pulled on its carriage by the crew, although some stations commandeered a horse for longer pulls.

On April 4, 1915, the tug *Mars* was passing Highland Coast Guard Station, towing three barges, when she ran into a ferocious storm. Unable to make headway in the gale, she was forced to release the barges to save herself. Grounded here on the beach were the barges *Coleraine*, *Tunnel Ridge*, and *Manheim*. The wheelhouse from *Coleraine* was later removed and became the Pro Shop at the nearby Highland Golf Course.

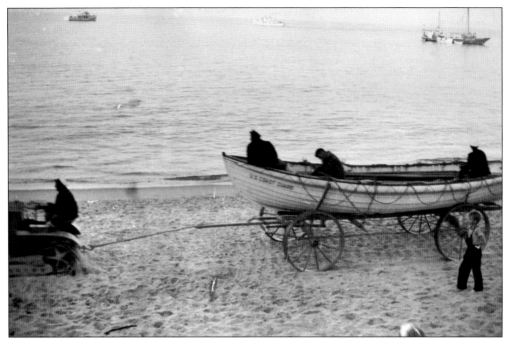

Following World War II, the Highland station had a crew of eight men, and its equipment included two trucks, an amphibious truck (DUKW), beach apparatus cart, and two pulling boats. Because of the low number of search-and-rescue cases, this station was consolidated with Cape Cod Light Station in 1947, and the name changed to Cape Cod Lifeboat Station. By late 1952, only the light station remained.

HIGHLAND LIGHT, CAPE COD.

During the 1700s, as commerce increased around the Cape Cod area, numerous vessels found themselves cast ashore near the clay pounds of Truro's highlands, on the Cape's outer reaches, and it soon became clear that a better means was needed to warn shipping from the shifting sands and shoals. In 1797, a 45-foot, octagonal, wooden tower—the first lighthouse on Cape Cod—was built. (*Harper's New Monthly* c. 1875)

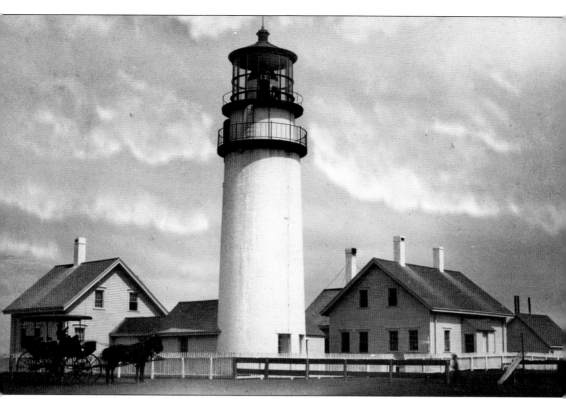

The light tower was constructed about 500 feet from the edge of the bluff, where it exhibited its light 160 feet above mean high water. A one-story dwelling for the keeper was also constructed, along with a barn, an oil-storage shed, and a well. By 1857, the light tower, now crumbling, required replacement, so the present white rubble-stone tower was constructed. With walls four feet thick at the base and a serpentine stair that winds its way up 66 feet to the watch room above, the tower remains to this day, although in a different location. Even in the 1850s, erosion of the cliffs was a problem, as it is today. Writer Henry David Thoreau noted during his famous walks in the area that in some years, whole sections of cliff had washed out. By the 1940s, this important seacoast light was the most powerful in New England, with a beam of four million candlepower from its first-order Fresnel lens. (Photograph by Nickerson.)

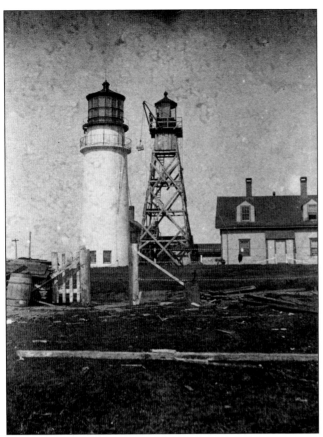

In 1901, a new first-order Fresnel lens was installed at Cape Cod Light. While work progressed, a wooden tower displaying a temporary beacon was erected. The new lens was constructed of highly polished glass prisms set in a brass frame, measuring about 12 feet high. This brilliant lens rotated on a bed of mercury, giving out a flash of 500,000 candlepower, one of the most powerful on the coast.

A clockwork mechanism, powered by a heavy weight hanging down the center of the tower, turned this powerful new lens to provide a half-second flash with a 4.5-second interval, with a four-wick oil lamp providing the illumination. In 1932, after the installation of electricity to the station, a 1,000-watt bulb would replace the oil lamp.

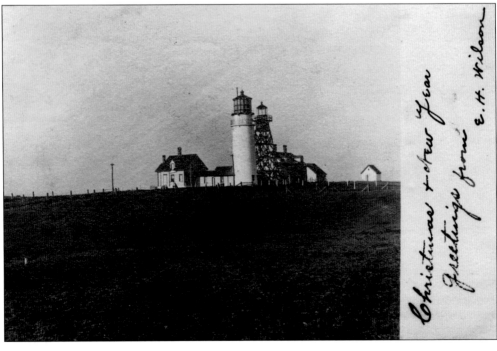

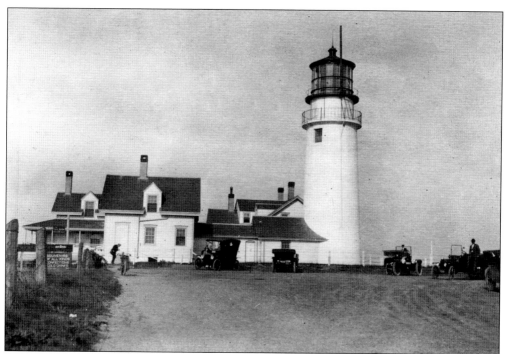

The lighthouse was a fine place for children to grow up. With three keepers and their families at the station, there was no shortage of company and other children to play with. In addition, there were the personnel at the Navy radio station and the ship-reporting agent Isaac Small and his family nearby. This light station on the edge of the Atlantic offered no end of adventure and amusement for the children.

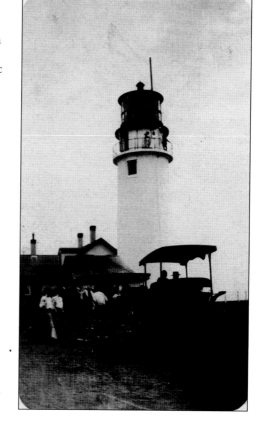

In the 1800s and early 1900s, there was also no end to the throngs of visitors at Cape Cod Light. Weather permitting, numerous fine horse-drawn carriages, each carrying its complement of finely dressed ladies with their gentlemen companions, would line the road leading to the light. If time permitted, one keeper would be kept busy escorting the crowds to the lantern gallery to enjoy the views.

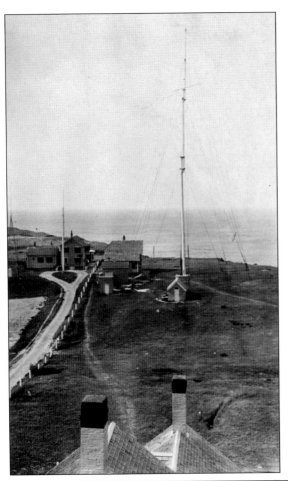

The buildings north of Cape Cod Light were once the home of the local marine observer Isaac Small. Small watched for passing ships from this vantage point, communicating their arrivals with marine agents in Boston. From this point too, incoming ships could be signaled and US Signal Service storm warnings displayed. In the 1920s, with the advent of radio, the US Navy Radio Station shown here was constructed for communicating with shipping.

When the first lighthouse was built in 1797, it was 500 feet from the clay cliffs, but by the 1990s, the present lighthouse stood just 100 feet from the edge. In 1990 alone, 40 feet were lost just north of the lighthouse. By 1996, sufficient monies had been raised to move the 404-ton light tower and keeper's house 450 feet farther inland. Shown is the station in 1948.

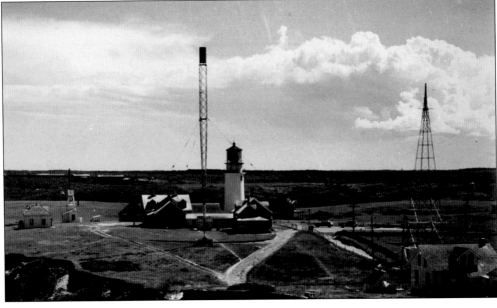

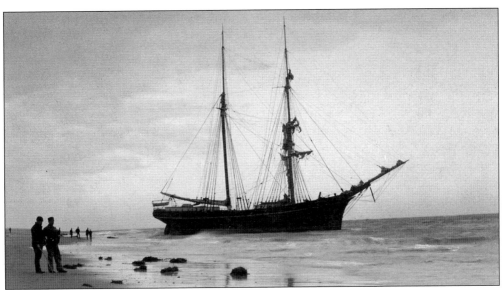

The Pamet (or Parmet) River is Truro's entrance to Cape Cod Bay. Little is known about the short-lived lighthouse constructed near the river entrance, possibly at Snow's Beach, at the mouth of the harbor in 1849. The lighthouse consisted of a lantern room built atop the keeper's house, much like the first lighthouse at Long Point in Provincetown. The lighthouse was discontinued in 1856 and sold. No known photograph exists.

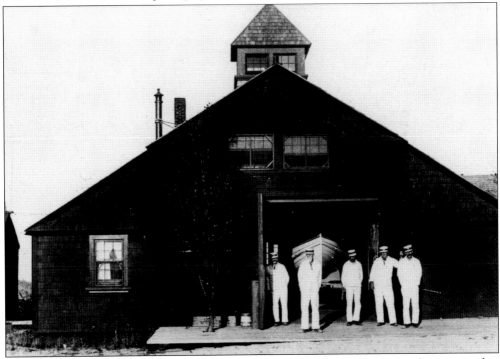

Three and a half miles south of Cape Cod Light was the Pamet River Life-Saving Station, another of the nine original stations. The station was of the Red House design and stood on one of the high sand dunes that line the ocean shore in Truro village. The station received extensive repairs and improvements in 1888, when it was modified to enclose the porch and add more space.

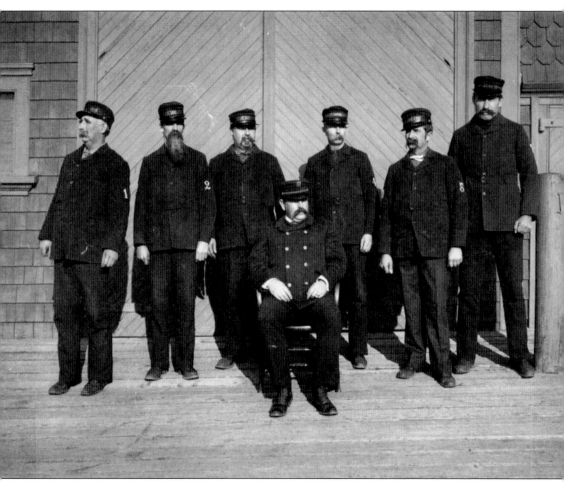

This rare 1908 photograph shows the Pamet River crew proudly posing on the station ramp. The crew includes, from left to right, Alonzo Nickerson, Isaiah T. Hatch, George Paine, Capt. George W. Bowley (seated), Richard F. Honey, Joseph H. Atwood, and Ephraim S. Dyer. Captain Bowley came from a family of lifesavers, his father having been a surfman at the High Head Life-Saving Station for some 18 years. At the time, Surfman Dyer was the most experienced surfmen in the Life-Saving Service on Cape Cod, with 36 years of service. He joined the service when it was established on the Cape in the 1870s and remained from then on. Like many surfmen, Dyer had spent a number of years as a fisherman and boatman on the shores of Cape Cod. Despite his many narrow escapes from death while performing his duty, he was still described as "hale and hearty and ever ready to respond to the call 'vessel ashore.'"

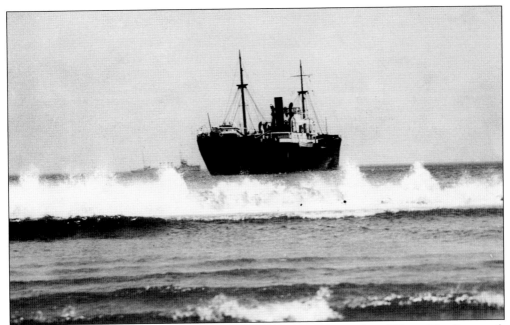

In 1927, the freighter *Ozark* rammed the steam trawler *Surge* in heavy fog off Truro. The *Surge* sank immediately; 19 crewmen went into the water and were rescued by the *Ozark's* crew, and 3 more were missing. The collision left the *Ozark* with a gaping hole, and she was forced beach herself three miles from the Pamet River Coast Guard Station. Only the calm seas prevented a larger loss.

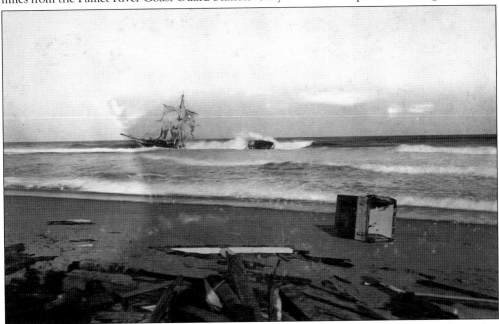

One of the worst disasters on the outer Cape was the wreck of the English ship *Jason* on December 5, 1893. Fighting a northeast gale, the *Jason* struggled to make her way past the tip of Cape Cod on her journey to Boston, but she was finally driven ashore on the bars at Pamet River. The ship was sighted by the patrols, and the lifesavers promptly responded to the scene. (Photograph by J.L. Rosenthal.)

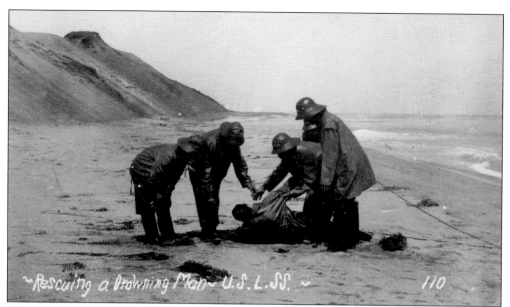

~Rescuing a Drowning Man~ U.S.L.SS. ~ *110*

Lifesavers fired a line over the craft, but 27 of the crew had perished almost as soon as the ship struck, and the efforts of the lifesavers were of no avail. A lone crewman, Samuel J. Evans, the ship's apprentice, was the only person that managed to reach the shore. The wreck of the *Jason* was one of the most appalling disasters that had ever taken place on the shores of Cape Cod.

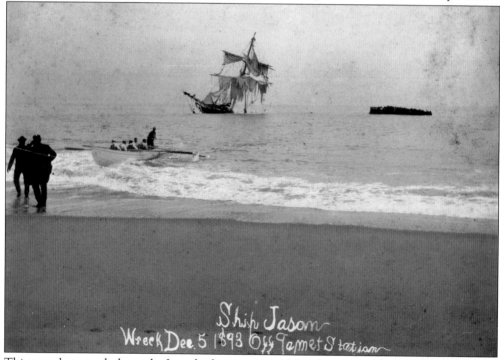

Ship Jason
Wreck Dec. 5 1893 off Pamet Station

This rare photograph shows the *Jason* broken in two, with her foremast and tattered sails defiantly standing as mute testimony to the disaster. In the foreground, a small group of men is ready to assist the Pamet Life-Saving Station's surfboat as she reaches the beach after having been out to survey the wreck and search for survivors.

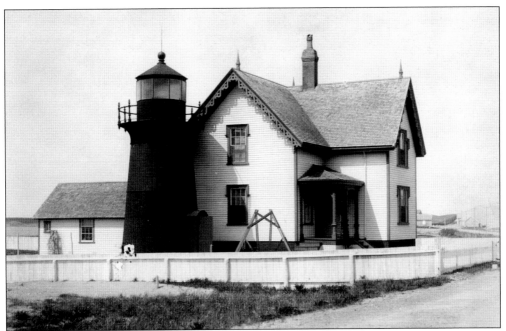

The first Mayo's Beach lighthouse was built in 1838 to mark Wellfleet's bustling harbor for its fishing fleet. The light was a short, wooden tower with octagonal lantern on the roof of a brick keeper's dwelling, much the same as the early light at Long Point. During the first four years of the lighthouse, there were three shipwrecks in the vicinity, including the 270-ton brig *Diligence*.

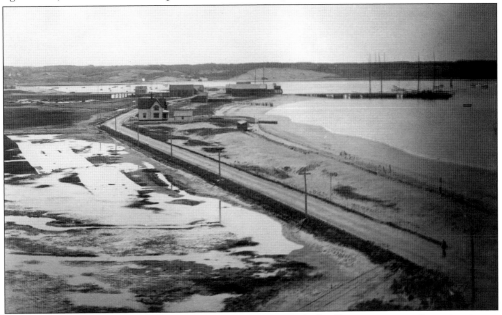

In 1880–1881, a new cast-iron tower and wooden keeper's dwelling was erected on the site to replace the deteriorating earlier structure. By the 1920s, with navigation improved, the light was discontinued, and the tower was removed to serve at Point Montara Light Station in California, where it remains today. Today, the keeper's house and oil house remain nicely maintained and can be viewed from Mayo's Beach.

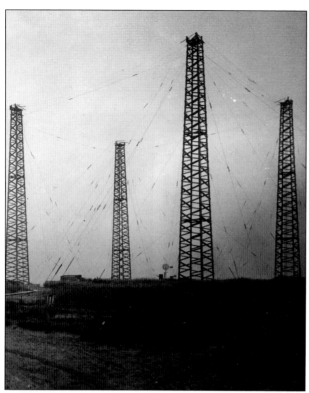

Another important location in Wellfleet was the Marconi wireless station CC (Cape Cod). By 1902, vessels quickly adopted Marconi apparatus to receive news and transmit messages. The South Wellfleet station became the lead North American facility for this function. The sound of the crashing spark from the large rotor, supplied with 30,000 watts, could be heard for miles. Messages relayed included communication with the steamer *Carpathia* during the *Titanic* rescue in 1912.

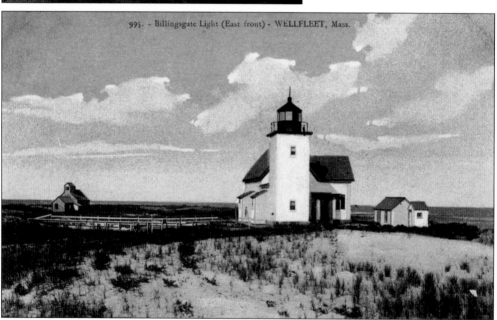

995. – Billingsgate Light (East front) – WELLFLEET, Mass.

Billingsgate Island once supported a thriving fishing community off Wellfleet in Cape Cod Bay. The island included 30 homes, a school, a tryworks, and soon, a lighthouse. By 1820, commerce required a lighthouse, and a brick tower and dwelling were soon completed. But by 1855, as the sea encroached, a new brick structure, almost identical to the first, was built higher on the small island. (Photograph by E.I. Nye.)

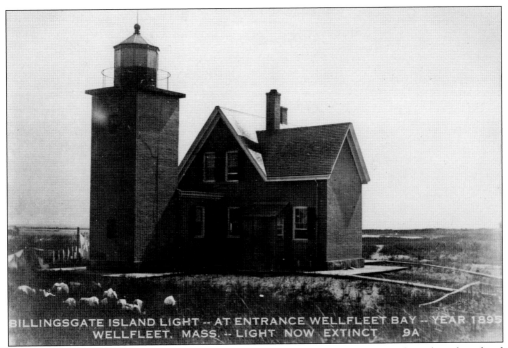

BILLINGSGATE ISLAND LIGHT -- AT ENTRANCE WELLFLEET BAY -- YEAR 1895
WELLFLEET, MASS. -- LIGHT NOW EXTINCT 9A

As time went by, the island continued to shrink. By the 1860s, it became clear that the island was washing away, and by the 1890s, water began washing through the keeper's dwelling. The keeper's logs reported, "High tide . . . flooded the tower floor to depth of 2 inches." By 1905, the island's inhabitants had gone, leaving only the keeper. The light was extinguished in 1915. (Photograph by Eastern Illustrating.)

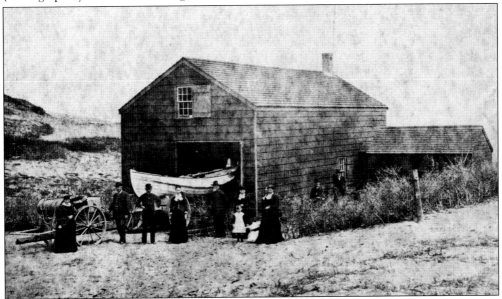

The Cahoons Hollow Life-Saving Station was another of the 13 outer beach stations, covering the area between the Pamet River and Nauset stations. The station was a Red House type and contained a lower boat-room level with a small living and cooking space, a small attic level for storage, and several cots for sleeping. The first station was destroyed by a fire in February 1893.

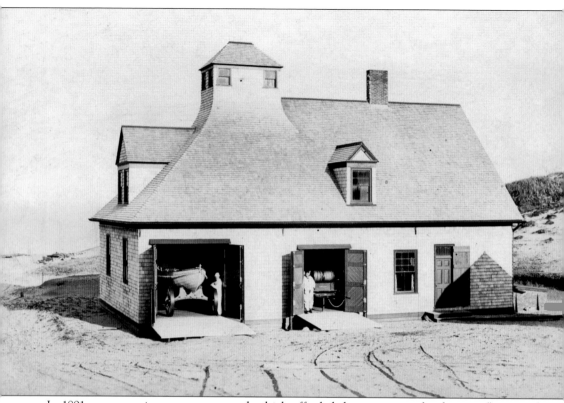

In 1891, a new station was constructed, which afforded the men space for three surfboats and equipment. The coast here was made exceedingly dangerous by sunken rips extending along the shore for miles. In February 1914, the Nauset and Cahoons Hollow stations responded to the stranding of the Italian bark *Castagna*, a scene of great hardship and suffering. The ship's crew, numbed by weeks of intense cold, had lost the use of their limbs, and many were swept overboard before they could be rescued. With great effort, eight sailors were rescued by lifesavers. Other casualties included Captain Tobin of the Cahoons Hollow station, who was badly injured by the overturning of the surfboat. This would be the largest loss of life in a wreck on Cape Cod in 12 years. Today, one can still visit the Cahoons Hollow station, now operating in the form of the Beachcomber Restaurant in Wellfleet.

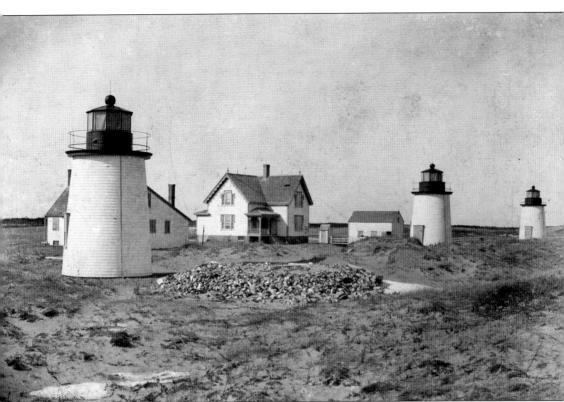

In the early 1800s, a method was needed to make lighthouses distinctive so that they would not be confused with other locations. Today, this is accomplished with distinctive flashes, but in the early 1800s, the problem was solved by building multiple lighthouse towers. Thus, to distinguish Nauset from Cape Cod Light (one tower) and Chatham (two towers), three brick light towers were erected there in 1837. The towers were 15 feet in height and 150 feet apart, with a brick keeper's house. The trio of towers acquired a famous nickname—the "Three Sisters of Nauset." The name is frequently said to have originated because the towers looked like three demure ladies in white dresses with black hats. In 1883, Keeper Stephen Lewis was transferred to Nauset Lights, where he would serve as principal keeper until 1914. He served there with his wife and two children.

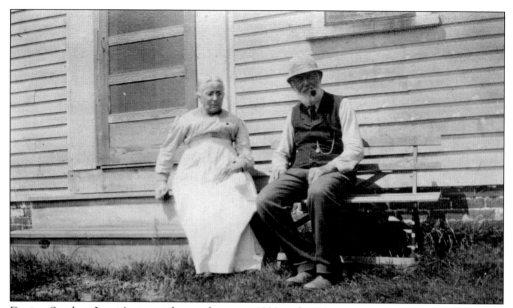

During Stephen Lewis's time as keeper between 1883 and 1914, many changes came to the Light-House Establishment, and Nauset Light station received sweeping changes to its configuration as well. In the 1880s, more-efficient oil lamps were installed in the towers to increase the lights' intensity and efficiency, giving them a visibility of over 15 miles. Shown is Keeper Lewis resting with his wife, Susan.

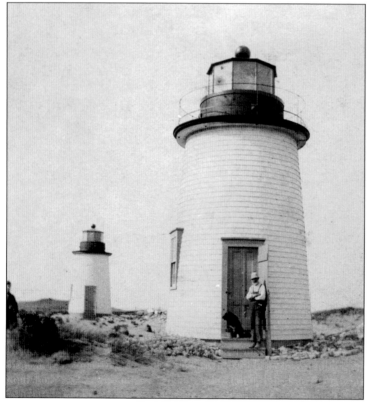

By 1911, the towers were threatening to topple over the edges of the eroding cliffs. The lighthouse inspector reported that the cliffs had eroded to within eight yards of the northern tower. In addition, with advancements in lens technology and the ability to differentiate stations by their flash rather than by the number of lights, three distinct lights at this location were no longer needed.

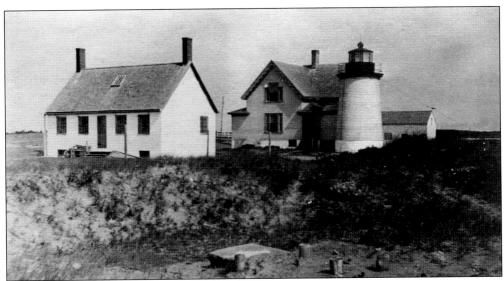

So in 1911, the north and south towers were extinguished and moved to the back corner of the lot. In 1912, the center tower was moved back onto a solid foundation that was attached to the 1875 principal keeper's house. With only one light and no assistant keeper required, the 1838 brick assistant keeper's house (seen here in front) was no longer needed and was soon demolished.

The old north and south towers were stripped of their lenses and lantern rooms and moved to a corner of the reservation to await their fate. After seven years, the two old light towers were sold in 1918 for $3.50 and moved down the road to be combined into a summer cottage, where they housed summer visitors and a dance studio for the next 45 years.

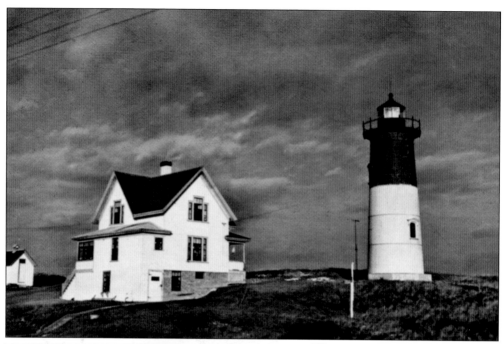

The center tower remained in service until 1923, when one tower from Chatham Twin Lights was moved to Nauset Beach and placed at a point farther from the cliffs. The 1875 keeper's dwelling was moved as well to a position adjacent to the new tower location. The remaining wooden tower was sold into private hands and moved elsewhere in town, where it too became part of a summer cottage. (Photograph by Mike Roberts.)

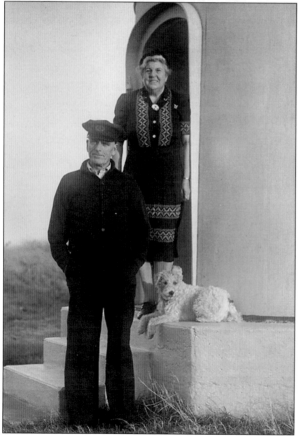

Shown is Keeper Eugene L. Coleman with wife, Amanda, in 1945. They served at Nauset from 1942 until 1950. Although they loved lighthouse life, Amanda often complained of the lack of another woman to talk with. The light was automated by the Coast Guard in 1955, and the keeper's house passed into private hands. The fourth-order Fresnel lens was replaced by modern aerobeacons in 1981.

Nauset Light remained until 1997, when it was again moved farther from the eroding cliffs. The keeper's house and oil house also remain, having been moved as well. The two early towers sold to the Cummings family in 1918 were purchased by the National Park Service, and in 1975, the third tower was bought from the Hall family. The three towers were reunited and restored on a Cable Road site.

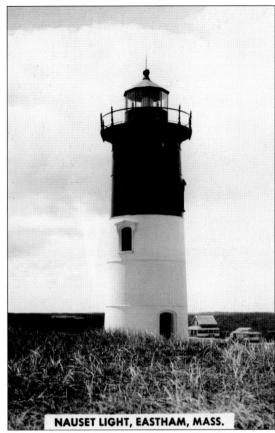

The Nauset Life-Saving Station was built in 1872 on the desolate stretch of beach two miles from the village of North Eastham, just south of the Nauset Lights. Shortly after its construction, erosion required that the station be moved 1,000 feet to the north. The Nauset Bars have been the scene of many terrible wrecks over the years, with the Nauset keeper and seven surfmen effecting over 55 rescues.

NAUSET LIGHT, EASTHAM, MASS.

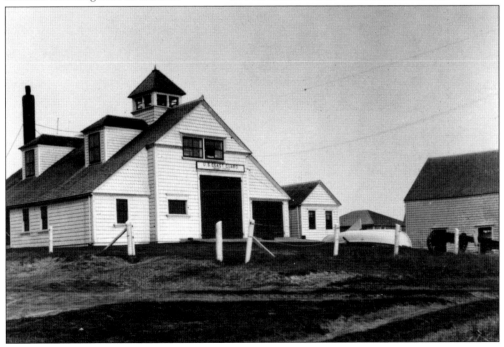

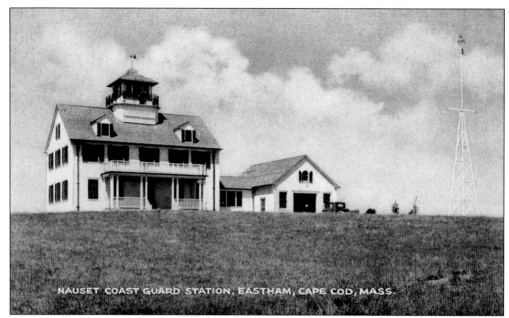

NAUSET COAST GUARD STATION, EASTHAM, CAPE COD, MASS.

The old station remained in service until 1937, when it was replaced by the present Chatham-type structure. It remained an active Coast Guard station until 1958. The building was turned over to the new Cape Cod National Seashore in 1961 to become their headquarters. Just south on the outer beach, there once stood the cottage where author Henry Beston lived while writing his acclaimed account, *The Outermost House*.

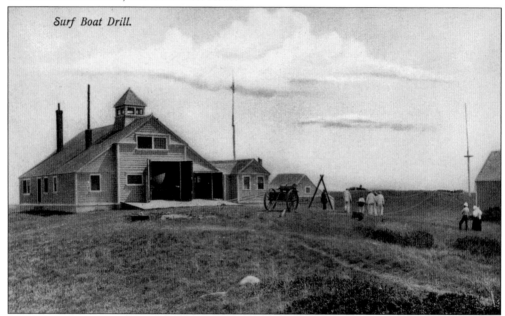

Surf Boat Drill.

By the turn of the century, the lifesavers at Orleans under Keeper James H. Charles had rescued over 100 persons from wrecked vessels. Beach patrols from this station covered two miles to the north and south, exchanging brass checks with surfman from the Old Harbor station. Equipment here included three surfboats, two beach apparatus carts with Lyle guns, faking boxes, and other equipment as needed.

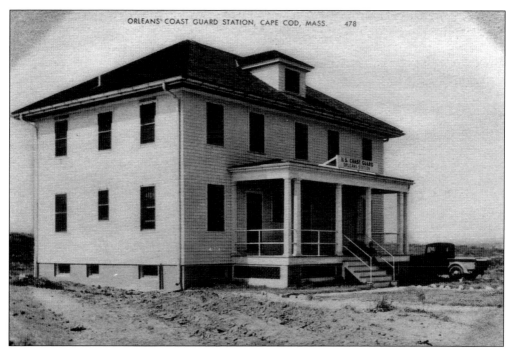

The station was located "abreast of Ponchet Island," on the back side of Nauset Beach, and south of Nauset Harbor. By 1922, it was listed as discontinued, but it was again active in 1928. Records show that men were assigned here during that period nevertheless. In 1933, WPA funds were used to reconstruct the station buildings, and the Chatham-type crew quarters were added. The station disappears from the listing of lifeboat stations in April 1947.

On August 26, 1939, in anticipation of the invasion of Poland, the Kriegsmarine high command ordered all German merchant ships to head to German ports immediately. The *Bremen*, returning to Germany from New York, likely lost two life rings that were later found in Orleans. From left to right, Coast Guard surfmen Ezekiel Fulcher, Virgil C. Spaulding, and Louis H. Silva of the Orleans Lifeboat Station found the life ring shown on September 6.

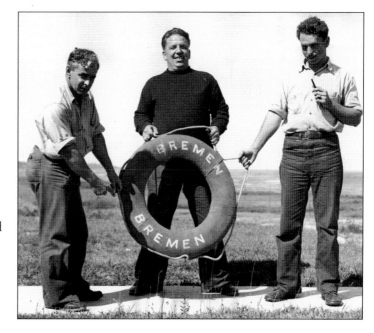

On March 10, 1909, the steamer *H.F. Dimock* collided with steamer *Horatio Hall* in Pollock Rip Slue off Chatham in the dense Cape Cod fog. The *Dimock* could not be seen from shore because of the fog, but her distress signals were heard at the Orleans Life-Saving Station. This collision, which sent the *Hall* to the bottom within half an hour, forced the *Dimock* to run ashore six hours later on the Orleans beach, a half mile south of the Orleans station. Following the collision, the passengers and crew of *Horatio Hall* had gone aboard the *Dimock* as the *Hall* began to sink on Pollock Rip Shoals. Lifesavers from the Orleans station launched a lifeboat and rowed to the *Dimock*. It had sustained hull damage and was in danger of sinking, so the lifesavers landed survivors and requested help from the Nauset and Chatham stations in saving the remainder of the people aboard the foundering steamer. The rescue work continued, and the remaining 67 passengers and crew were landed without loss of life.

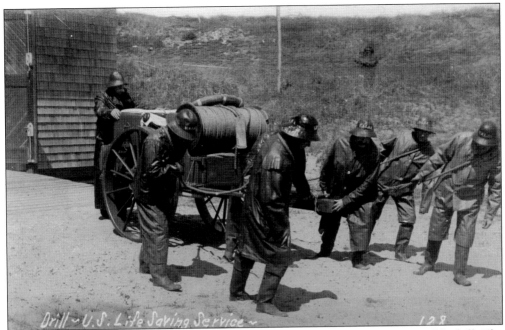

The Cahoons Hollow lifesavers pose with their beach apparatus cart before a weekly drill. The breeches buoy apparatus was used to rescue sailors when their vessel was stranded sufficiently close to shore to be reached by shot line from the lifesavers' Lyle gun. Drills were held regularly in all aspects of rescue work, including flag signaling, first aid, restoration of the apparently drowned, and other skills.

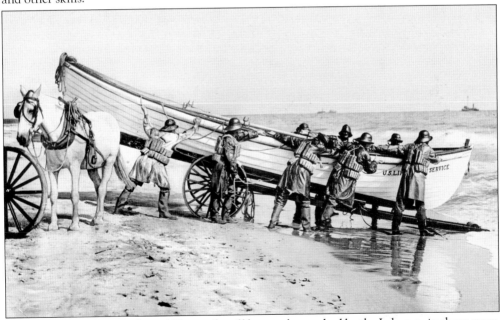

Many times, the shipwreck would be too far offshore to be reached by the Lyle gun; in these cases, the surfboat would be used. This too would be hauled on its four-wheeled carriage down the beach to a point suitable for launching. Watching for the proper time, the keeper would direct his men to push the boat into the water, jump in, and begin to pull toward the wreck.

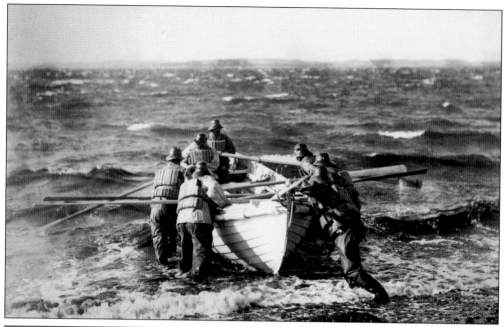

When launching the surfboat, timing with the breakers was critical, and many surfboats were overturned or wrecked in the breakers. After rowing for hours, the lifesavers would finally begin to approach the wrecked vessel. The keeper would draw on his years of experience and knowledge of the sea to approach the wreck in such a way so as not to be dashed to pieces against its side.

Despite the hardships, and no matter how high the seas, surfmen of the Life-Saving Service had a remarkably high record of success. Once on the scene, more often than not, they managed to rescue all or most of those on board a stricken vessel. In the 39-year history of the Life-Saving Service, the odds of a mariner's survival approached 99 percent.

Three

MASSACHUSETTS HUMANE SOCIETY

Much like the Light-House Establishment, the institution of life-saving services to rescue and provide succor for shipwrecked sailors dates back over 250 years. At about the same time that the colonies were realizing the need for navigational aids, the citizens of Massachusetts were becoming more concerned about the incidents of shipwreck and loss of life along the coast. As the 18th century was drawing to a close, winter storms continued to take their toll on shipping in the dangerous waters surrounding Cape Cod and, indeed, all of Massachusetts. Increasingly, shipwrecks occurred along the coast with the loss of not only the valuable vessels and cargos, but many times, their crews as well. Sometimes, shipwrecked sailors were able to make their way ashore only to perish on desolate beaches from lack of shelter. This looming crisis caught the attention of notable Boston businessmen, and on January 5, 1786, a group established the organization to be called the Massachusetts Humane Society. Many prominent citizens would become members, including founder of Harvard Medical School Dr. John Warren, coppersmith and noted revolutionary Paul Revere, John Hancock, Massachusetts governor James Bowdoin, and many more. Funded entirely by private donations, the Massachusetts Humane Society began by erecting houses of refuge to shelter shipwrecked mariners along remote sections of the treacherous Massachusetts shorelines. These small, one-room structures measured eight feet square, had a stove and chimney, and were stocked with firewood, water, and blankets to sustain sailors until they could summon aid. The huts were positioned in locations that allowed shipwreck victims who had made their way to shore to find them readily. By 1802, houses of refuge on Cape Cod included one near Race Point, one at Stout's Creek in Truro, one at Nauset Beach, one between Nauset and Chatham Harbors, and two on Cape Malebarre (Monomoy). Over time, additional huts were constructed along the coasts, and signs were erected to point the way to the huts for sailors who were lucky enough to reach the beach.

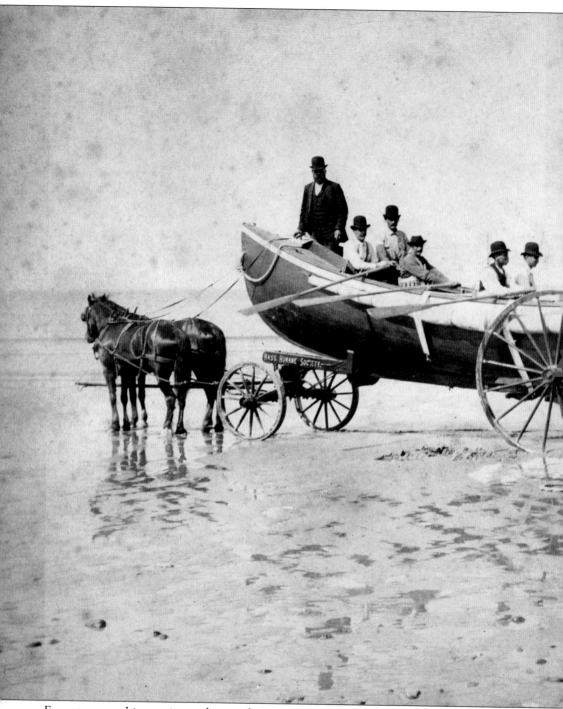

Eager to expand its service to shipwreck victims, in 1807, the Massachusetts Humane Society decided to have a lifeboat specially constructed for rescue, with a building to house it. The cost of the boat amounted to $1,433, and the craft was placed in the Humane House (boathouse) in Cohasset later that year. As more wrecks followed, a renewed emphasis was now placed on erecting additional stations and building shelters along the Massachusetts coast. Soon, boathouses too were

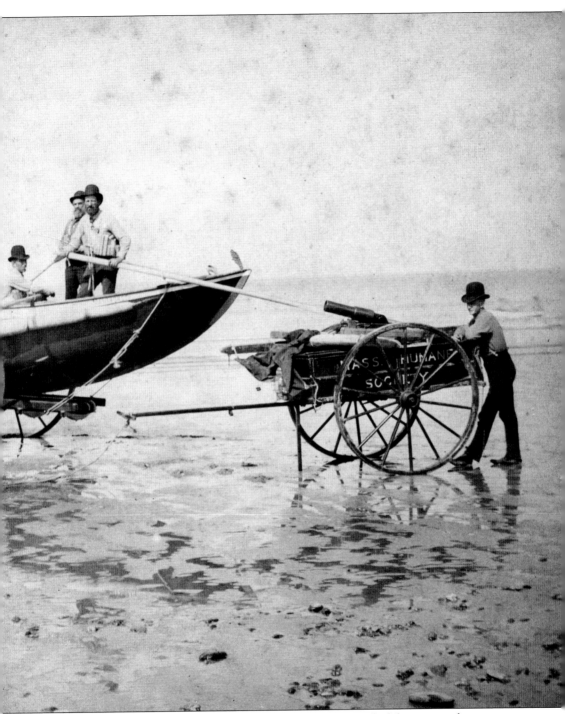

constructed on Cape Cod to be manned by local volunteers, mostly fishermen and watermen. These boathouses measured 20 feet long, 8.5 feet wide, and were painted red for visibility. By 1841, the Massachusetts Humane Society had expanded to include 81 stations along the Massachusetts coast, including 18 boats and rescue equipment.

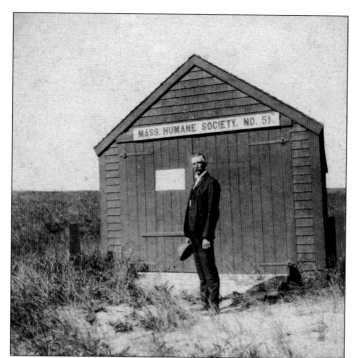

In addition to the huts of refuge, by the 1880s, many additional stations had been established on Cape Cod, including Barnstable (boat and house), Sandwich (21-foot boat), Race Point light (boat and Hunt gun), Nauset Harbor (boat), Orleans (boat), Cuttyhunk (lifeboat and Hunt gun), and at Cuttyhunk Light (two boathouses with boats). In time, more stations would be equipped with line mortars, breeches buoys, dories, and other apparatus.

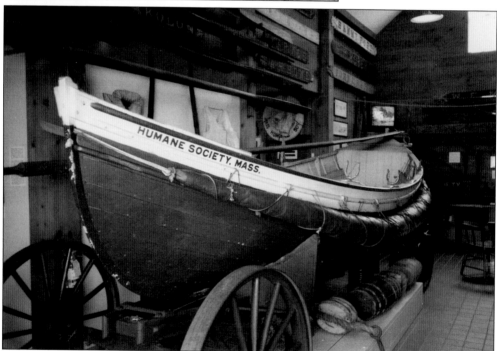

By the 1870s, with the expansion of the US Life-Saving Service, the growth of the Massachusetts Humane Society would come to an end, but the volunteers would continue to be a valuable asset when needed. They would often work hand in hand with the government lifesavers during large storms requiring multiple rescues. Many of their stations would remain active well into the 20th century. (Courtesy Nantucket Shipwreck & Life-Saving Museum.)

Four

THE LOWER CAPE

George Hibbert Driver in his *Cape-scapes* (Boston, 1930) noted: "When the Lord wished to show that beauty—sea, sky, sand dune, shadow of hillock, sparse sea grass and shallow spreading tide of shore scenes now fertile, now heated with Nature's death—existed, he set Cape Cod like a rainbow at the canting tip of Massachusetts eastwards."

The Lower Cape, or Cape Cod's "elbow," consists of the towns of Chatham, Harwich, and Brewster. Some say that this area of stately captains' homes and sandy inlets, washed by the tides, is one of the loveliest on the Cape. Driver's description continued, "From its shore run out myriad little fingers of land, making a coast-line which is a maze of 'blue inlets and their crystal creeks' . . . and the land itself, torn into such exquisite tatters."

But it is just these features, charming and beautiful to the casual visitor, that at the same time make the area a dread to mariners. The shore is continually in a state of change. As inlets are scoured open or shut with shifting sand, one spot is washed away, while another is built up. The region, like a fine lace, is strewn with freshwater and saltwater ponds, inlets, and sandbars, all mingling with the ever-changing shoreline.

Add to this the often-present fog shrouding the area like a veil, and with the long arm of Monomoy stretching out to the south, it is no wonder that the history of this area is punctuated with hundreds of shipwrecks. Some wrecks were so memorable that they find their names repeated to this day—*Sparrowhawk*, *Somerset*, *Jason*, *Eldia*, and, of course, the pirate ship *Widdah*. But hundreds of others, no less tragic, have been lost to time. In 1853 alone, there were no fewer than 23 shipping disasters on the shores of the outer Cape.

It is no wonder then that by the 1870s, shipmasters were demanding that rescue stations be built on these alluring shores.

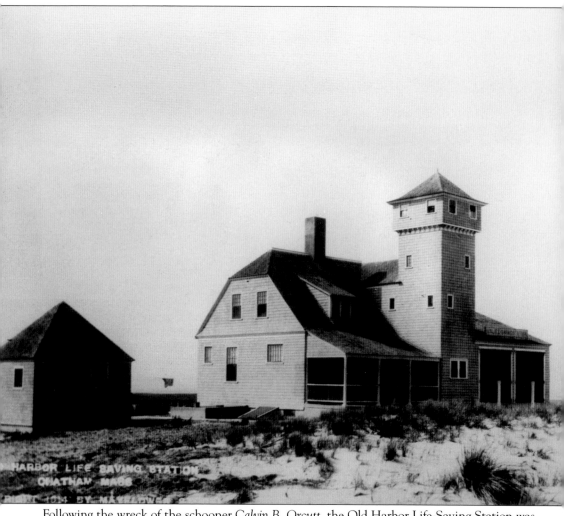

Following the wreck of the schooner *Calvin B. Orcutt*, the Old Harbor Life-Saving Station was placed in commission on Chatham's North Beach in 1898. The station, small and plain, was set on a sand dune, out of reach of high water and painted red so as to be visible from the sea. On the first floor were a mess room, which served as a sitting room for the crew; a kitchen; a keeper's office with bed; and a boat room. On the second floor were two rooms: one with cots for the crew, the other for survivors of wrecks. In the first five years of operation, Keeper Doane and his crew rescued 21 persons in their surfboat and brought 13 shipwrecked sailors ashore in the breeches buoy. The station was provided with two surfboats, beach carts, breeches buoys, and a Francis metallic life car.

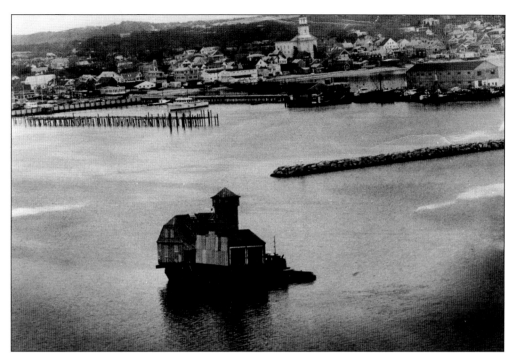

The Old Harbor station served throughout most of World War II but was decommissioned in 1944. Following the establishment of the Cape Cod National Seashore, the building was obtained by the National Park Service in 1977 and moved by barge to just south of the Race Point station in Provincetown. Today, this rare period life-saving station has been beautifully restored and equipped and is open to visitors in the summer.

The first pair of lighthouses on the cliffs at Chatham was completed in 1808. The contractor had intended to construct the towers of local stone, but he soon found that the outer Cape is composed of sand—there was no stone to be had. So the first twin lights were constructed of wood and made movable on skids so that they could act as range lights and retreat as the shoreline changed.

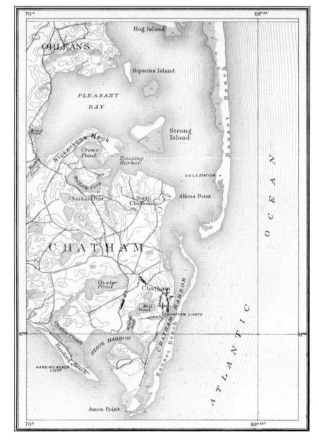

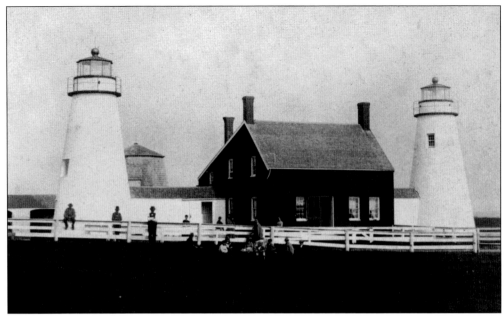

The lamps used in the towers were designed and installed by inventor Winslow Lewis. Each tower contained six lamps, each with eight-inch, silvered reflectors and green glass lenses. By 1841, the lights were discontinued as the offshore channel changed too suddenly for them to be of much use. New masonry lights were constructed in 1841 and lasted until between 1877 and 1881, when two new cast-iron towers were placed in service.

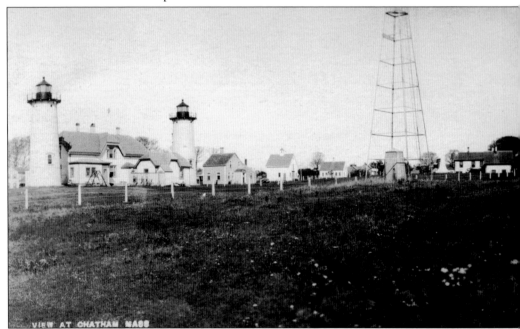

The original lighthouse on Jamie's Bluff in Chatham was the second to be completed on Cape Cod. The twin cast-iron towers and dwelling shown here, the third set on this site, were constructed in 1881 to replace previous towers threatened by the sea. Each tower was identical—cast-iron plates lined with red brick. Inside each, a circular, iron stairway spiraled up to the lantern. The

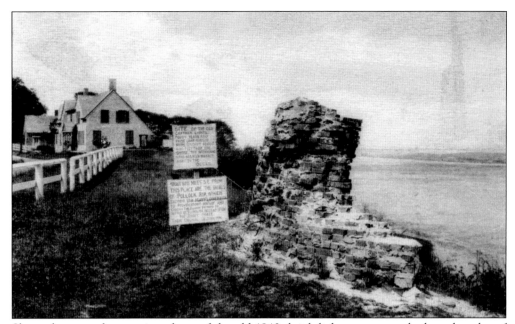

Shown here are the remains of one of the old 1840s brick light towers, perched on the edge of the sand cliff. Captain Hardy, keeper at Chatham in the 1870s, carefully recorded the erosion of the cliff. In 1870, the lights were 228 feet from the bluff, but by 1874, the distance was 190 feet. By 1876, a mere 95 feet remained, and they soon toppled over.

iron ball on top of the lantern-room roof was perforated to allow heat from the lamps and the sun to escape. Then, as now, encroachment by the sea continued to be a problem. By 1879, the last remains of the brick towers had fallen into the sea.

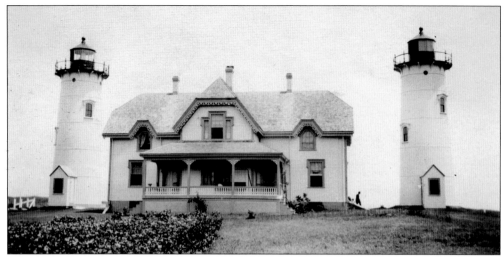

By 1922, the remaining "Three Sisters" tower at Nauset beach was in need of replacement. By then, rotating and flashing techniques had been perfected, so multiple lights were no longer needed. In 1923, the north (right) cast-iron tower at Chatham was moved to Eastham to replace the weakened wooden tower there, and a rotating fourth-order lens replaced the fixed lens in Chatham's remaining south tower.

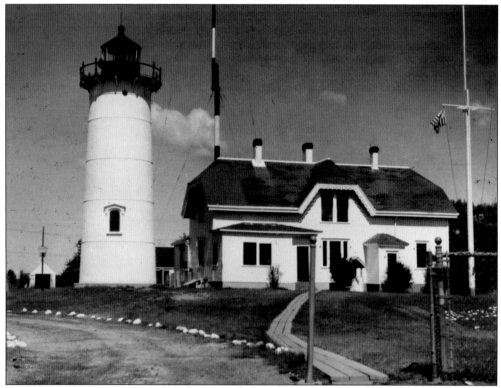

Shown here in 1949, the south tower and original 1881 keeper's dwelling remain in Chatham today as US Coast Guard Station Chatham. In 1969, the lantern room was replaced. The original lantern and Fresnel lens can be seen intact today as a wonderful exhibit outside of the Chatham Historical Society on Stage Harbor Road. This new light can be seen a distance of 28 miles at sea.

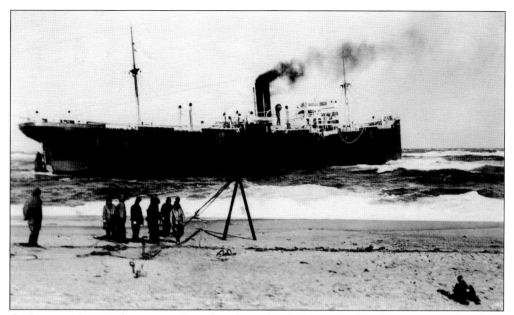

On January 13, 1907, the steamer *Onondaga*, bound for Jacksonville, Florida, was stranded in thick fog on the beach north of Old Harbor Life-Saving Station in Chatham. Despite the high seas, the lifesavers went to her aid to rescue the stranded crew. The first shot from the lifesavers' Lyle gun hit its mark on the deck, and soon the crews had the breeches buoy apparatus secured.

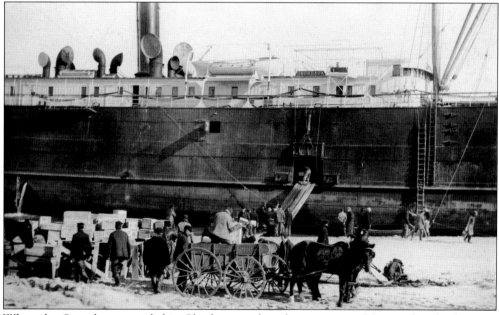

When the *Onondaga* grounded in Chatham, on board was a cargo of dry goods valued at over $150,000. To remove the vessel, the owners hired local help to carry the cargo to wagons for the transfer by land. Some time later the vessel was refloated and returned to service. In 1918, while headed for France, she would strike the rocks and sink off Watch Hill, Rhode Island.

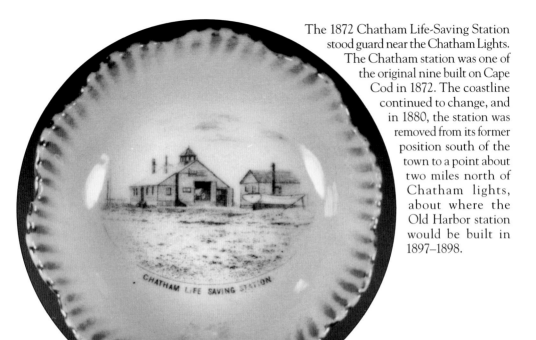

The 1872 Chatham Life-Saving Station stood guard near the Chatham Lights. The Chatham station was one of the original nine built on Cape Cod in 1872. The coastline continued to change, and in 1880, the station was removed from its former position south of the town to a point about two miles north of Chatham lights, about where the Old Harbor station would be built in 1897–1898.

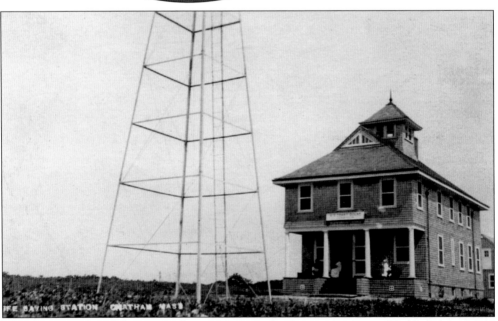

The station remained there only about 15 years before being again moved back to its original site on the northern end of Monomoy. Some time in the 1940s, the station compliment was transferred to the Chatham Lighthouse building, and in 1955, the old station was transferred to the Fish and Wildlife Service. Coast Guard Station Chatham is still in operation at the Chatham Lighthouse site today.

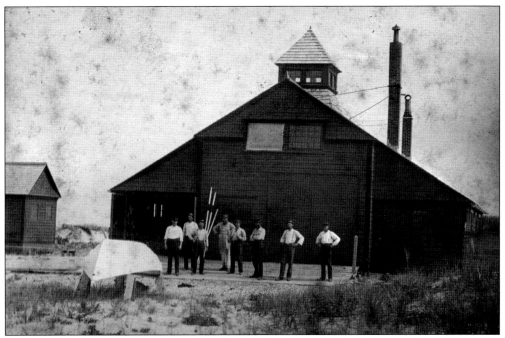

The life-saving station south of Chatham at Monomoy was erected in 1873. There was no more dangerous section of the seacoast than this small spit of sand. Eight surfmen were employed here instead of the usual six or seven, and in 1902, these men would prove their worth. Early on March 11, 1902, the barge *Wadena* was stranded off Monomoy during a gale, and her sailors struggled to unload her cargo.

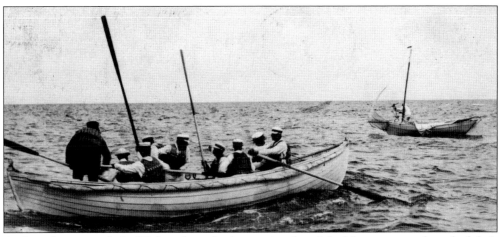

As the gale increased, the *Wadena* showed a distress signal, and the Monomoy crew launched their surfboat. Aboard were Keeper Marshall Eldredge, Surfman Seth Ellis, and six other surfmen. After a long pull, the crew was able to pull alongside and, with great effort in towering seas, bring aboard five stricken sailors. While returning to the beach, the surfboat took a wave over the side.

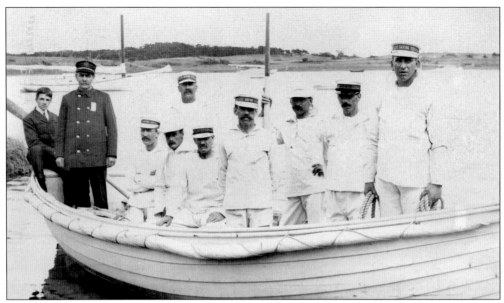

The rescued sailors panicked and interrupted the work of the surfmen, causing the surfboat to roll over. Two successful efforts to right the boat resulted in it being rolled over again. The cold water soon took its toll. One by one, the lifesavers fatigued and fell away. The last, Surfman Ellis, shown here in the dark uniform, was rescued just in time by Elmer Mayo. Ellis would be the only survivor.

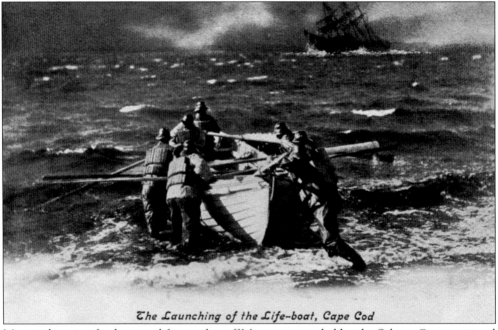

The Launching of the Life-boat, Cape Cod

Memorial services for the seven lifesavers lost off Monomoy were held at the Orleans Congregational Church and at churches across the Cape. Captain Mayo, "Hero of Monomoy," received coveted life-saving medals from both the Massachusetts Humane Society and the federal government for his efforts in rescuing Surfman Ellis as he clung to the surfboat. After his recovery, Ellis was made keeper at the Monomoy station.

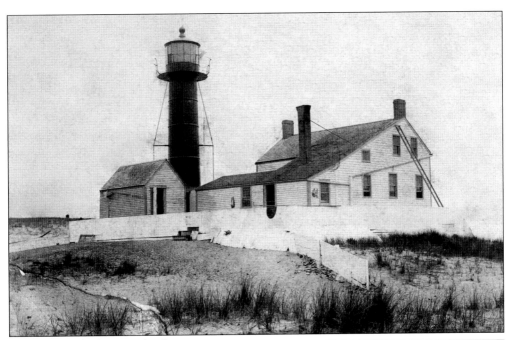

Monomoy is the barrier island jutting south from Chatham into shipping lanes of Nantucket Sound. In 1823, after many terrible wrecks, a wooden dwelling with a light was finally constructed near the tip. The tower was rebuilt a number of times before this unusual red cast-iron tower was constructed. The tower was 40 feet high and showed a white light with a red sector marking Pollock Rip Slue.

When the Chatham lights were upgraded in 1923, it was felt that they effectively guarded Monomoy as well, so the light at Monomoy was discontinued. However, this singularly beautiful dwelling and brick-red tower remained intact for over 65 years. The property passed into private hands and was used for hunting and summer living until 1964, when the Massachusetts Audubon Society restored the lighthouse and keeper's house.

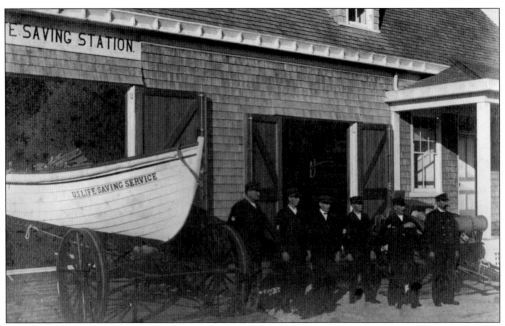

The dreaded Shovelful and Handkerchief shoals stretch out along the eastern and southern shores of Monomoy Island. Countless vessels have met their doom there, and many lives have been lost. Owing to the great number of disasters that occurred off the southern end of Monomoy, the Monomoy Point Life-Saving Station was built between 1902 and 1904. The station was located southwest three-fourths of a mile from Monomoy Point Light.

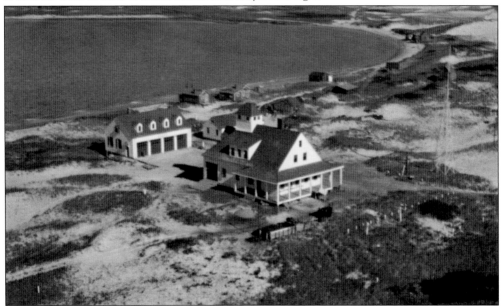

When this station was erected, it was intended that the old Monomoy station be abandoned, but after the *Wadena* disaster, the decision was made to keep them both open. In 1921, extensive repairs and remodeling of the station included installation of modern heating and toilet facilities. The station was still active in 1945 but was closed by April 1947. The property was eventually demolished. (Photograph by Service News Co.)

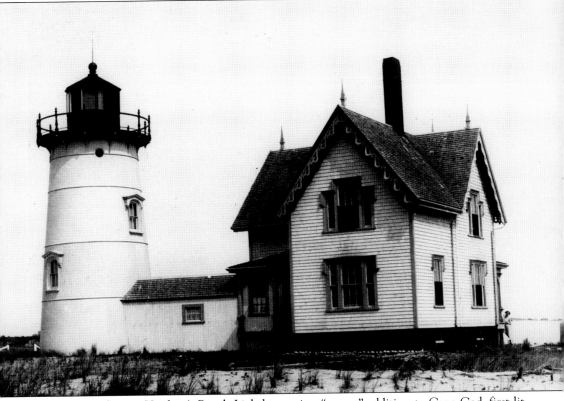

Old Stage Harbor, or Harding's Beach Lighthouse, is a "recent" addition to Cape Cod, first lit in 1880. The area is one of the foggiest spots on the East Coast. Known as a "harbor of refuge," Stage Harbor was needed as a safe haven for ships at night or as they transited Pollock Rip. The cast-iron tower and dwelling cost $9,882.74, and the light showed a beam from its fifth-order lens until 1933. In 1906, Alfred A. Howard was appointed keeper; he would serve here for 10 years. Howard was commended in 1912 "for courtesy extended" to a party of five whose boat ran out of fuel. Keeper Howard towed their catboat into port and transported the party to shore. In 1913, he was credited with saving Surfman Walter C. Harding of the Monomoy Life-Saving Station when his dory capsized.

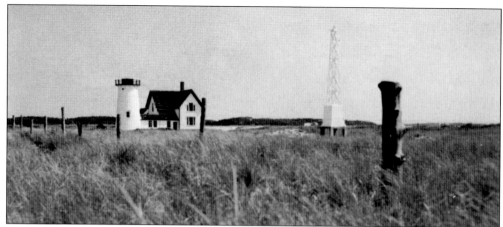

Keeper Howard received still another commendation in 1914 for helping to save a man's horse, mired in the mud, from drowning as the tide came in. In 1933, the light station was deemed excess and sold to the Hoyt (Ecker) family, whose descendants still lovingly preserve and maintain the property today. The dwelling and lanternless tower remain and can be seen from the public beach. (Photograph by Peter Smolens.)

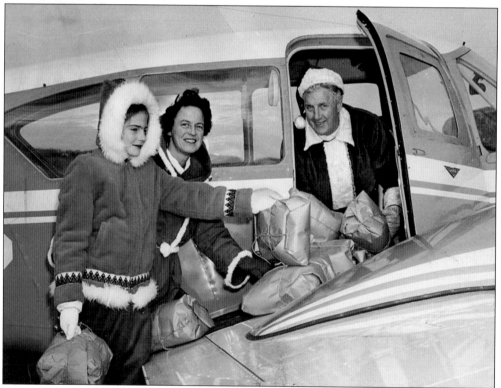

Edward Rowe Snow, author, lecturer, and historian, spent his life studying the lighthouses and legends of the New England coast. Snow is credited with over 100 books and pamphlets, and thousands of newspaper articles, lectures, and tours of the area. With his wife, Anna-Myrle, and daughter Dorothy, Snow made hundreds of visits to light stations throughout New England, including trips to continue the "Flying Santa" tradition of flying Christmas packages to remote light keepers' families.

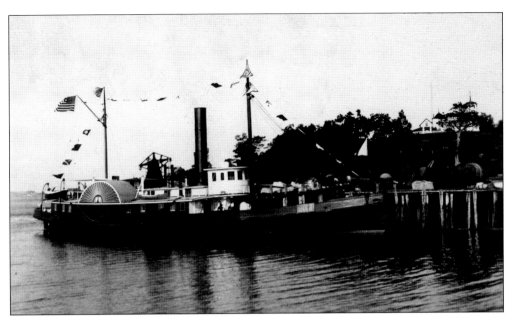

The lighthouse tender *Geranium* serviced lightships and light stations in the second district in the 1890s. Built as a steam tug in 1863, she was purchased for $42,000 by the Navy and served off the South Carolina coast during the Civil War. In 1865, she was sold to the Light-House Establishment, where she was lengthened to 155 feet and would serve until 1909 before being condemned and sold.

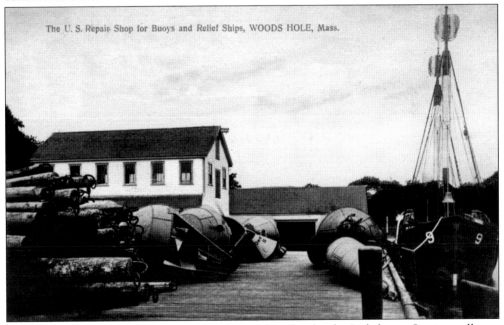

The U. S. Repair Shop for Buoys and Relief Ships, WOODS HOLE, Mass.

Lighthouse depots would continue to be the supply point for the Lighthouse Service well into the 20th century. Shown here is the Woods Hole Depot in 1909. From here, supplies would be distributed to light stations and lightships along Cape Cod and Nantucket Sound. Lightships were brought here for repair, and here, too, buoys were repaired, painted, and loaded on tenders to be set in place. (Photograph by Souther Mears.)

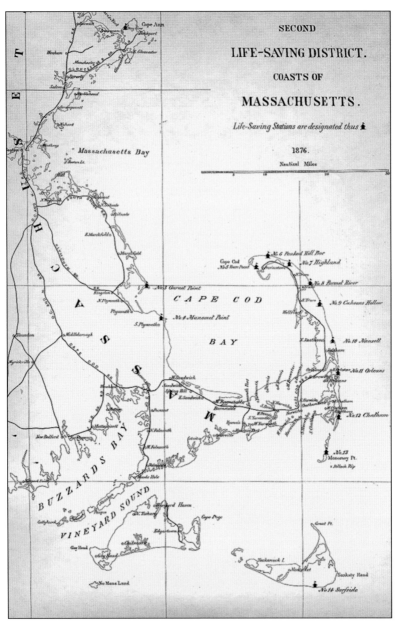

Throughout the 1870s and 1880s, the Life-Saving Service continued to expand its line of stations along the coast. From an occasional house of refuge or boat station manned by dedicated volunteers, Superintendent Kimball began to add new stations manned by paid, well-trained crews. In the service's first decade, Kimball was responsible for constructing nearly 100 new stations around the country. Decayed buildings were abandoned, and the stations were relocated to more appropriate spots. The addition of these new stations soon began to pay dividends as the tragic toll from shipwrecks began to stabilize, and then fall, for the first time in years. By 1914, the Second Life-Saving District, comprising the coast of Massachusetts, would boast 32 stations, each spaced approximately four to six miles from the next. Cape Cod would boast 13 stations, and Cuttyhunk, one. Over time, the entire coastline in the United States would be linked by over 200 stations, and the loss of life from shipwreck would be dramatically reduced.

Five

US Life-Saving Service

In March 1847, the first meager federal appropriation was made to provide rescue or assistance to victims of shipwrecks. The funds were used to assist the Massachusetts Humane Society in maintaining 16 boathouses and several houses of refuge. After years of continued lobbying, the following year, Congress saw an amendment sponsored by Rep. William A. Newell of New Jersey to appropriate $10,000 to provide "surf boats, rockets, carronades, and other necessary apparatus for the better preservation of life and property from shipwreck on the coast of New Jersey." Thus began the first federal Life-Saving Service in the United States.

With these funds, eight lifeboat stations were constructed and furnished. These stations were equipped with the latest galvanized-iron surfboats; Francis metallic life cars complete with air chambers, rubber floats, and fenders; rockets and mortars; ropes; powder; heating stoves; firewood; lanterns; and shovels.

By the following year, Congress appropriated an additional $20,000 to extend and equip eight more lifeboat stations on the coast of Long Island and New Jersey, and in time, additional lifeboat stations were constructed at Watch Hill, Rhode Island, and in the Carolinas, Georgia, Florida, and Texas.

In September 1854, the "Great Carolina Hurricane" swept up the East Coast, causing the deaths of hundreds of sailors and civilians. This storm highlighted the continued poor condition of the equipment in the life-saving stations, the poor training of the crews, and the need for more stations.

Over time, Congress would appropriate additional funds for a full-time keeper at each station and superintendents to oversee the operations. Still, this was not enough. Trained, full-time crews were desperately needed as alarming losses continued to occur. During the winter of 1870–1871, several large disasters finally awakened Congress, forcing them to appropriate the unprecedented sum of $200,000 to reorganize and expand the Life-Saving Service throughout the country. The funds enabled the service "to employ crews of experienced surfmen at such stations as . . . might [be] deem[ed] necessary and proper . . . for . . . more effectually securing life and property on" the coasts.

Now, they needed to find a leader to reorganize the service.

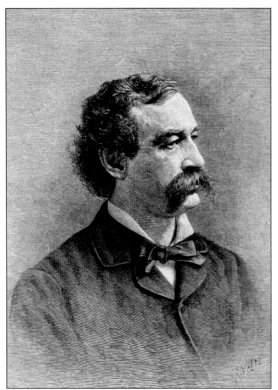

Probably the most important event resulting from the reorganization was the appointment of Sumner I. Kimball as chief of the Revenue Marine Bureau in February 1871. Kimball would be charged with responsibility for the fledgling Life-Saving Service and would become the driving force behind the United States finally possessing a first-class life-saving organization. Kimball set out to repair the deficiencies. Regulations were rewritten and stations added.

Crews of six surfmen were employed for a term of one season—from August or September through April or May of the following year. In difficult areas, an additional man might be employed from October 1 to May 31. If a man was found to be competent and performed satisfactorily, he would be reengaged for successive seasons. The men were designated No. 1, No. 2, and so on, according to their competency.

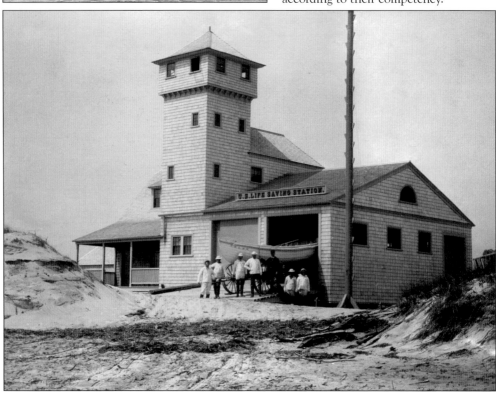

The average distance between stations was reduced to approximately three miles, and a system of signals was established. Of particular importance was the introduction of a patrol system whereby surfmen, by actually patrolling on foot, maintained a vigilant and constant watch of the nation's coastline throughout all weather conditions. In addition, surfmen stationed in the watch tower maintained a vigil during daylight hours.

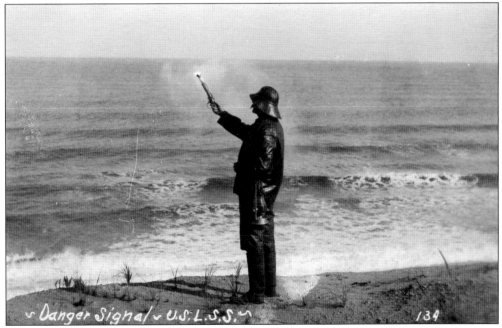

Patrolling surfmen would keep a keen watch for debris on the beach, indicating that a wreck had occurred. When a wreck was spotted on patrol, the surfman would ignite his red Coston signal flare both to alert the tower watchman and as a signal to survivors on board the vessel that help was on the way. The surfman would then return to the station to report to the keeper.

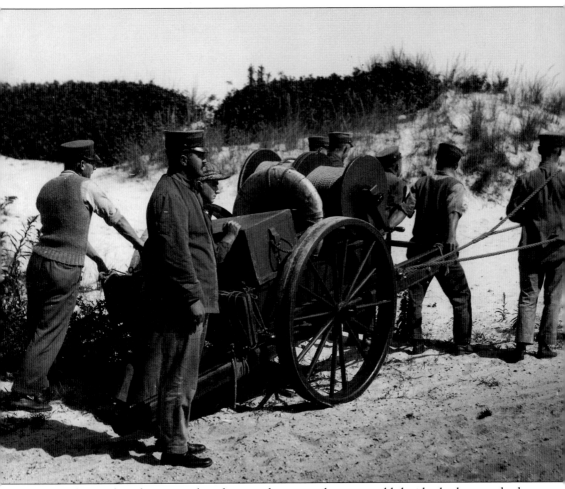

Upon being alerted to a vessel in distress, the station keeper would decide the best method to make the rescue, which would depend on the distance of the wreck from the beach. The methods of rescue at the keeper's disposal included breeches buoy, life car, or rescue by surfboat. Breeches buoy or life car would be the usual choice when the vessel was within about 600 yards of the beach. When either of these options was chosen, the surfmen would harness themselves to the beach apparatus cart for the long pull down the beach. On the cart were coiled reels of shot line, heavy hawser, as well as faking boxes to keep the coiled line from tangling. To gain access to the vessel with a line, a small bronze cannon called a Lyle gun was used. (Courtesy Jeff Shook.)

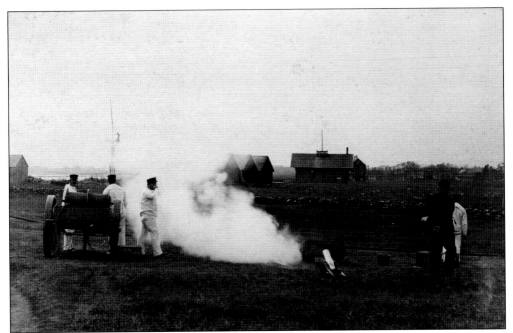

An iron projectile was fired into the ship's rigging, trailing the thin shot line. Surfmen were able to direct the projectile with great accuracy. Sailors on board the stricken vessel would use the shot line to haul aboard the larger hawser and fasten it to the ship's mast. Then, the shore end of the hawser would fastened to a sand-anchor and tension pulled.

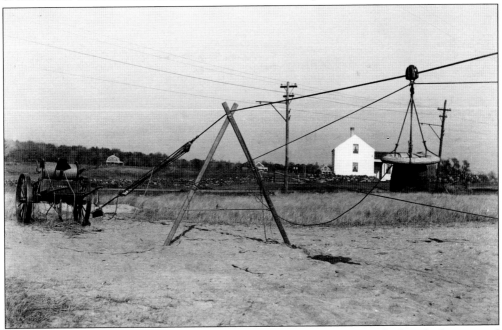

A life ring with canvas pants, known as a breeches buoy, was then attached to the hawser and sent out to the vessel. One by one, the passengers and sailors would climb into the breeches buoy and be pulled to safety. Over the 39-year history of the Life-Saving Service, tens of thousands of lives were saved using this method.

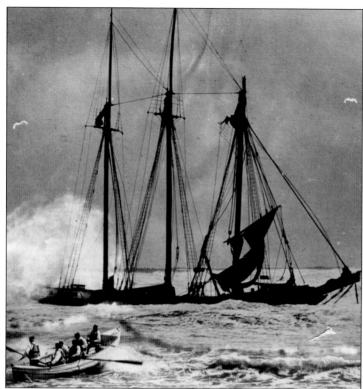

If the wreck was farther than 600 yards, the lifesavers would employ the surfboat. Rowed by six men and steered by the keeper in the stern, the surfboat was a sturdy craft, able to brave treacherous seas and still remain stable. Some wrecks, miles off the beach, required hours to reach, and trip after trip might be needed to bring all the survivors ashore.

U.S. LIFE SAVERS
EXHIBITION DRILL AT
MICHIGAN CITY - IND.

In addition, Superintendent Kimball began testing improved surfboats, which would soon become standard equipment at all stations. Among the drills that Life-Saving Service personnel were required to perform was the surfboat capsize drill. The ability to right a surfboat overturned by the sea was most important to the lifesavers' survival, as evidenced by the disaster off Monomoy in 1902. Crews practiced weekly to become adept at this procedure.

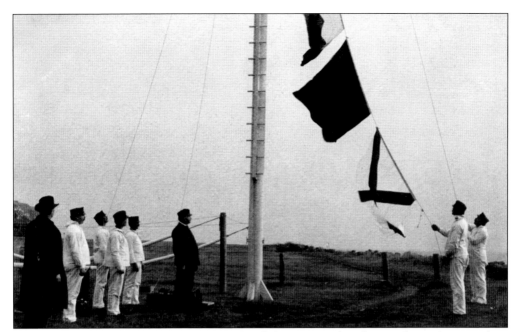

Life-Saving Service Regulations were quite detailed, requiring that the men be proficient at their tasks and able to fill any position. Each day's activities were specifically laid out: Monday was for station cleaning and maintenance; Tuesday, drills in launching and landing the surfboat; Wednesday, signal-flag communications; Thursday, drills with beach apparatus and breeches buoy; and so on. Saturday was for wash and Sunday, for religious pursuits.

If the keeper was married, he was allowed to have his family reside with him at the station. His wife might be employed to cook for the crew, or else the men would rotate the responsibility. The keeper was the only person whose family was allowed to stay at the station. The crew's families lived in town, or they might build a small home nearby so they could visit more often.

The crew's time off was spent in numerous ways, depending on the weather. Many men were skillful hunters and used the time to supplement the station food supplies from the plentiful waterfowl and fish in the area. Some men carved and painted their own duck decoys, which can still be found in local shops today. A few can be found branded with the station's "U.S.L.S.S." mark.

The keeper worked a full 12 months, earning $900 per year, while the surfmen were paid $40 per month. By 1902, their pay had increased to $65 per month. From May to August, the surfmen would return home to take care of their affairs and supplement their income, usually by farming or fishing. Each spring, articles of engagement would again be signed, employing each man for the oncoming season.

By the mid-1870s, improvements to the service began to bear fruit. In three seasons of work, only three lives had been lost within the range of Life-Saving Service activities. There would be setbacks, but very quickly, the service began to be recognized as the best, most efficient, and effective in the world thanks to increased congressional support and Kimball's able administration.

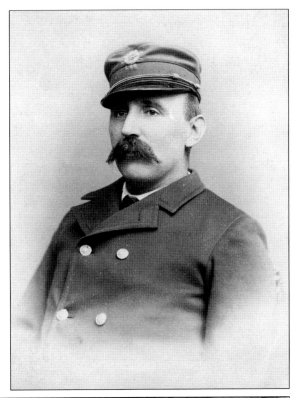

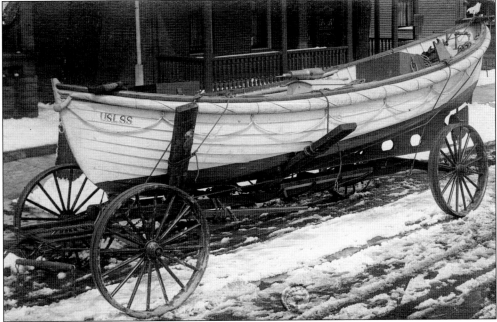

By about 1910, the Life-Saving Service began converting from pulling (oar) boats to the new, motorized lifeboats. Though engines were still in their early stages of development, they afforded the lifesavers the ability to extend their range many miles and to be less exhausted upon arrival at a wreck. Thus, they would be better able to perform their rescue duties.

Over its lifespan, the Life-Saving Service built up a tremendous rescue record, though sometimes with the loss of its own men. Many books—such as *Storm Fighters, Heroes of the Surf, Guardians of the Sea, Uncle Sam's Life-Savers, Rulers of the Shoals*, and others—were written about these heroic lifesavers as they brought back thousands of sailors and passengers from the clutches of the sea. Without hesitation, the crews would go out through hurricanes, blizzards, and the fiercest of seas. The 1899 Regulations of the Life-Saving Service, in Article VI, Section 252, required that the men attempt the rescue and that the keeper "not desist from his efforts until by actual trial the impossibility of effecting a rescue is demonstrated." But nowhere in the regulations did it say that the men had to come back, and some did not. During the period of operation of the Life-Saving Service from 1871 to 1914, crews responded to 28,121 vessels in distress, rescuing over 178,000 persons.

Six

THE MID-CAPE

During the early years, the best lighthouse keepers were found in many cases to be retired seamen. Sailors were accustomed to standing watches at night in the most adverse conditions. Such men generally had a strong work ethic, which made them most suitable candidates for such positions. The Light-House Board wrote shortly after their establishment in 1852: "Upon the keeper depends, in great measure, the efficiency and steadfastness of the light under his care . . . The usual routine of their practice consists in lighting up at twilight, and then trimming between eleven and twelve at night," after which the keeper would keep a constant vigil to insure a clean bright light.

One of the greater disadvantages of the position of keeper at the time was the low rate of salary allowed, which reduced the pool of good men seeking the position. It was felt that the meager pay would not command the services of hardworking and intelligent men, such as were required to do justice to a valuable and costly apparatus.

Despite the years of experience on the sea that many keepers possessed, the life for the keepers was often difficult at best. One keeper noted at the time, "When winter comes on, with its storms of sleet, wind and driving snow, a black gloom settles over his white tower which not even his bright beacon light can pierce. Then the days are short, and the night watches are long . . . Storms tear up the shining beach and strip the cliffs of foliage. They send the ocean straight up like a gray wall, thundering against the grim heights."

But despite the difficulties, the keepers and their families persisted and generally made a good working community that got along very nicely together. Their homes were pleasant and secure. Although it was a big job to keep the light and station clean and operating properly, few keepers would ever seek to change their lot.

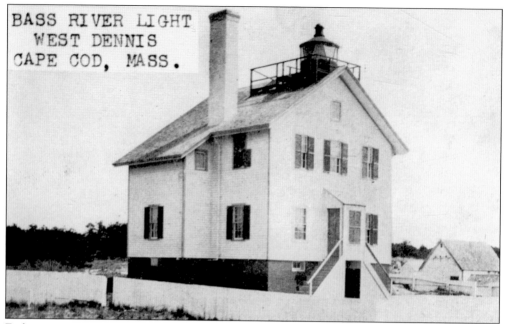

Early on, captains near Bass River in East Dennis saw the need for a beacon and began to contribute 25¢ apiece for a lantern to be shown from Warren Cromwell's window on Wrinkle Point. As traffic in the area increased, so did the demand for a lighthouse. By 1850, the government agreed that a light was needed and purchased a site near a breakwater at the mouth of the river.

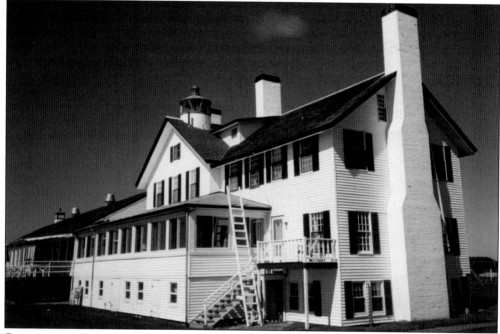

Soon, construction of a two-story, wood-frame keeper's house with the lantern protruding from the roof began. The light went into service on April 30, 1855, with a fifth-order Fresnel lens displaying a fixed white light. Today, little has changed, and the light remains as part of the Lighthouse Inn, where guests may sleep in a room just below the light.

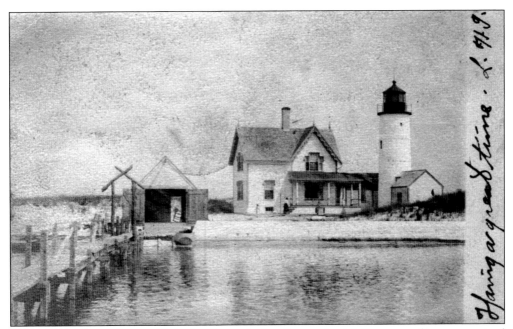

Having a good time. 1919.

From the beginning, Barnstable harbor boasted a bustling trade with Boston, and it soon required a lighthouse. After the wreck of the *Almira* in 1827, a lighthouse was established at Beach Point on Sandy Neck. The first light was a tower and lantern on the roof of the keeper's dwelling, similar again to the first Long Point Light, a common Cape Cod style in the early 1800s.

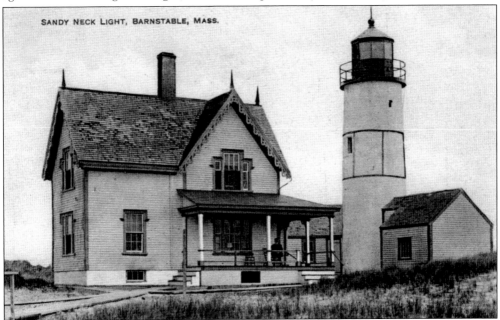

SANDY NECK LIGHT, BARNSTABLE, MASS.

In 1857, a new, 48-foot, brick tower was erected just north of the first light. The distinctive iron hoops and staves that surround the light tower were added in 1887 in an effort to strengthen it, as cracks were beginning to appear. As Barnstable Harbor declined in importance, the lighthouse was decommissioned in 1931, and the property was sold. Today, the tower and keeper's house remain in private hands.

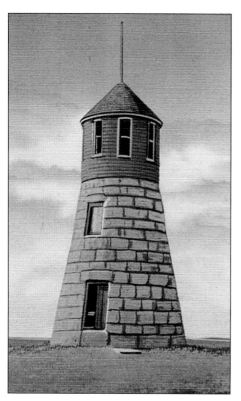

The Point Gammon Light was one of the earlier lighthouses in this area, erected in 1816 to mark what is now Great Island. The tower and dwelling were built of whitewashed fieldstone and, by the 1850s, boasted 11 lamps with 14-inch reflectors, showing a fixed white light. The light was discontinued shortly after 1858, but the stone tower remains today on private property. (Photograph by H.L. Moore.)

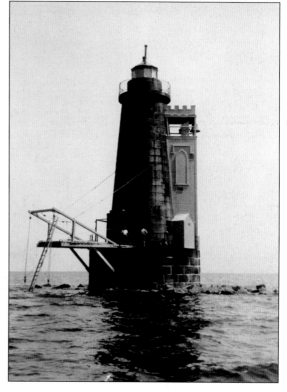

Bishop and Clerks Lighthouse once marked the remains of a large reef just south of Hyannis Harbor. In the 1850s, Congress approved funds for a tower here, and the light was lit in 1858. The granite tower stood 59 feet above the water and boasted a distinctive wooden bell tower. In 1928, the light was deemed unnecessary, and in 1952, it was dynamited by the Coast Guard.

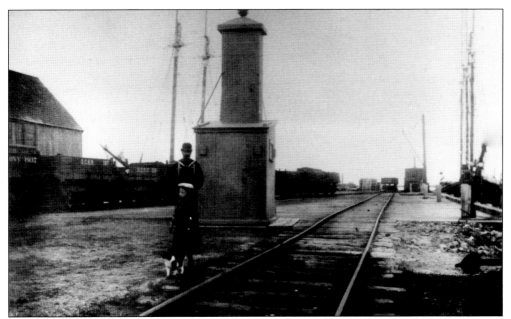

As the population and shipping continued to grow, a better means to guide vessels into Hyannis was needed. In 1885, this wooden range light was erected on the wharf. Admont Clark, in his book *Lighthouses of Cape Cod*, notes, "When Captain John Peak was at the light he had a running battle with the railroad, because they would often leave freight cars next to the beacon, blocking it." (National Archives photograph.)

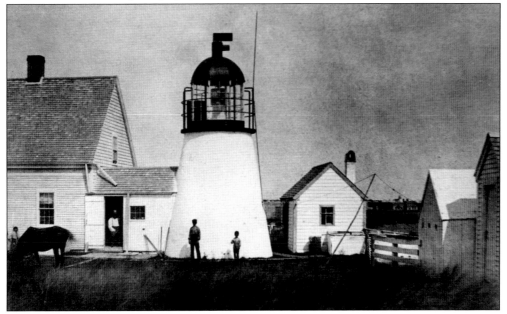

The South Hyannis Light was built inside the breakwater in 1849 to guide shipping into Hyannis Harbor. The tower was of masonry, fitted with three lamps and reflectors. In 1850, a Cape Cod–style dwelling was constructed, connected by a short walkway. As was common, the keepers were changed nearly as often as the presidents, and this station saw eight keepers before being decommissioned in 1929.

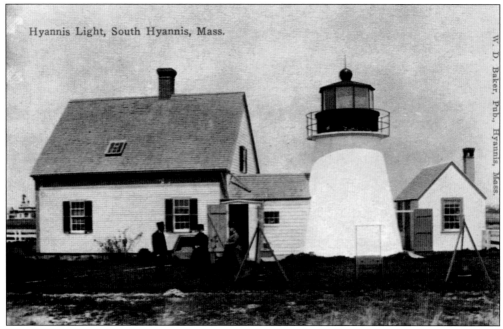

Hyannis Light, South Hyannis, Mass.

W. D. Baker, Pub., Hyannis, Mass.

The 1850s tower at South Hyannis Light was updated in the 1880s and fitted with a new Fresnel lens, but by 1929, a light at this location was deemed unnecessary. The property was eventually sold at auction, and the basic tower structure can still be seen today, attached to the original dwelling, although greatly modified and considerably larger.

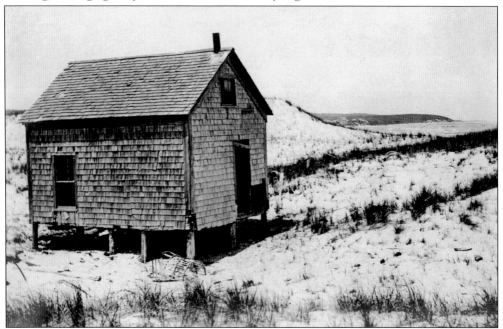

Well into the 1940s, surfmen continued to patrol the beaches at night and throughout the day during storms. At the limit of a surfman's patrol area, sometimes three to four miles down the beach, there was erected a hut or halfway house. These huts were fitted with a stove and supplies, and here a surfman could rest a bit and warm up before retracing his steps back to his station.

Seven

THE LIGHTSHIPS

Lightships came into use in the United States in 1819 and were used to mark offshore shoals where a lighthouse could not be constructed. The years between 1820 and 1983 saw the establishment of 116 lightship stations, 19 being in Massachusetts waters. Lightships had a number of advantages: they could be moored near shifting shoals where no fixed structure could be built, and they could be moved when shifting sands demanded, or moored in deep waters to serve as a landfall for transoceanic shipping traffic. However, being on these exposed positions placed them at high risk for collision and damage from storms. These stalwart crews were required to keep their vessels on station despite any weather or sea conditions that might arise, for passing ships depended on their lights to guide them.

As one might imagine, crew conditions on board these early vessels were close to uninhabitable, as budgets were low and the builders had little concern for the crews. Crews were forced to endure rolling, violent pitching and severe storms, resulting in frequent loss of anchors and moorings and damage to the vessels. Ultimately, designs would improve, but the service was not without serious losses. Lighthouse Service records contain over 200 instances of lightships being blown adrift or dragged off station in severe weather or moving ice. In addition, monotony and the danger of collision were always present, and 150 collisions were logged, with five light vessels lost and many more damaged.

Nantucket sound once boasted the largest concentration of lightships anywhere in the world. Up to five light vessels marked the Shovelful and Stonehorse Shoals from the 1840s until the last one was removed in the 1960s. In addition, six other lightship stations marked other hidden shoals in the area. Even today, these constantly shifting shoals continue to claim ships from time to time.

All of these light vessels are gone from their stations now, having been replaced by silent, expressionless buoys. Less than a dozen light vessels remain afloat today. A few are preserved as museums, a testimony to the courage and perseverance of their crews.

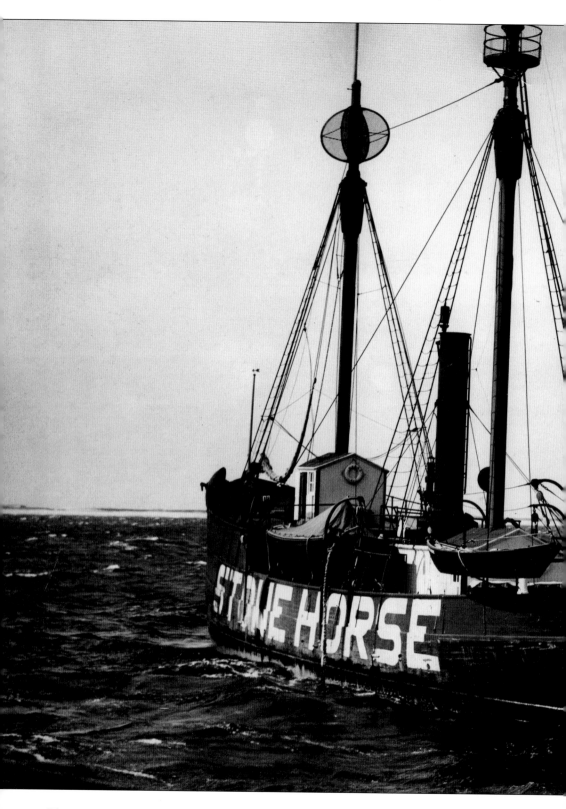

Heading out to sea through Nantucket Sound, past Monomoy Point, there lies a series of shoals that have plagued mariners over the centuries. Off the tip of Monomoy is the rocky Stonehorse reef. Stonehorse Light Vessel (LV) No. 47 is shown on station in April 926 with Monomoy Island beyond. Once, Monomoy Lighthouse and two life-saving stations guarded this important link in Cape Cod's sea commerce. Note the lantern house is still in service at the base of the foremast. Looking closely, one can see the spare mushroom anchor lashed to the port rail near the bow. It may have been just such an arrangement that failed on the Vineyard Lightship No. 73 during a fierce hurricane in 1944, causing the anchor to swing down and hole the hull, resulting in the loss of the vessel with all hands.

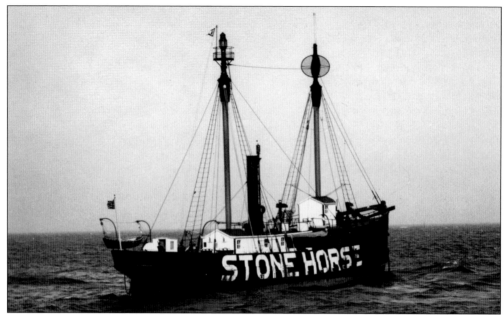

Such lightships were constructed of steel framing, planked with the finest Georgia pine, and sheathed with white oak. Vessels had one or two daymarks on the masts to aid in recognition during daylight hours. The lantern on the main mast was initially lit with oil; this was changed to acetylene in 1924. Fog-signal equipment included a 12-inch steam-powered chime whistle and a hand-operated, 1,000-pound bell.

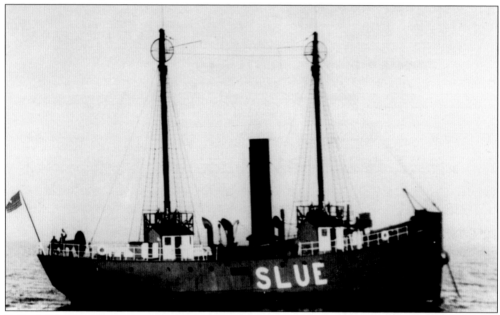

Pollock Rip Slue station was established in 1902 just four miles north of Pollock Rip Lightship in the Monomoy Passage. Lightship No. 73 served on this station for 21 years. In 1921, during a northeast gale, boarding seas demolished the whale boat, smashed the after skylight, broke the wheel, and washed the binnacle overboard. Despite such constant hardships, the vessel's crew was credited with a number of rescues over the years.

In *The Lightships of Cape Cod*, Frederick L. Thompson notes that Pollock Rip Shoals Light Vessel No. 42 "was blown off station so many times that she gained the nickname 'The Happy Wanderer.'" In 1880, a driving storm blew her off station, and she was towed back by the US Revenue Steamer *Gallatin*. In spite of her heavy moorings, she was again blown out to sea in 1882, 1886, and 1887.

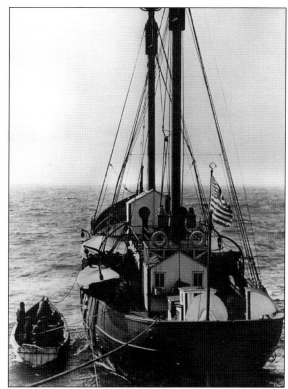

Shown here are officers on board Pollock Rip Shoals Light Vessel in 1913 enjoying some quiet time reading at the mess table. Off-duty time was spent as one might expect—reading or writing letters home, playing board games, carving wood toys or animals, or fishing over the side to supplement their menu. Occasionally, passing vessels would drop off the mail, recent newspapers, or a treat of fruit, if available.

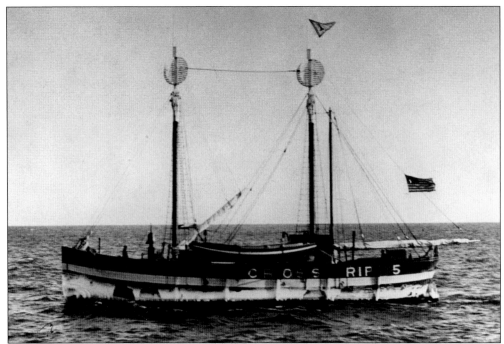

Cross Rip Shoals lies between Nantucket and Martha's Vineyard. On Christmas Day 1866, the weather looked ominous as First Mate Charles Thomas took charge of Light Vessel No. 5. Soon, the vessel was engulfed by a ferocious gale, groaning with each wave. Both anchor chains parted. Weeks passed with no word until February, when the crew was picked up, adrift and far out to sea, by a passing steamer.

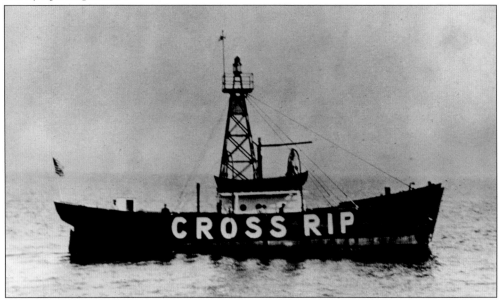

Cross Rip Light Vessel No. 6 served on station from 1916 until 1918. In the winter of 1918, arctic cold blasted the area for weeks, freezing the area and trapping four light vessels in miles of ice. After weeks, the ice broke up, and the small light vessel was torn from her moorings, only to be dragged by the ice pack over the shoals and lost with all hands.

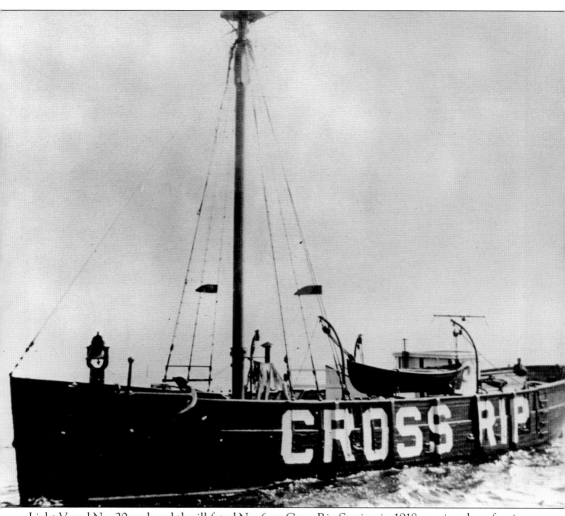

Light Vessel No. 20 replaced the ill-fated No. 6 on Cross Rip Station in 1918, serving there for six years. The crew would ring the fog bell on the bow by hand constantly whenever fog warranted, many times for days on end. It was soon decided that she was too small for use during New England winters at such an exposed location, and she was transferred in 1923.

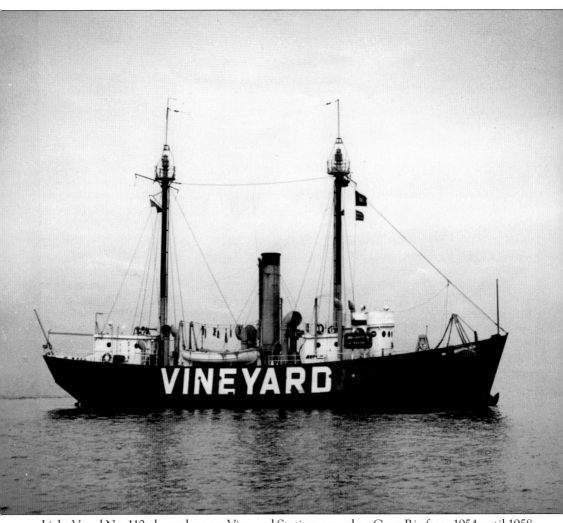

Light Vessel No. 110, shown here on Vineyard Station, served on Cross Rip from 1954 until 1958. She was built in 1923 of all-steel construction, was 132 feet in length, and served on six East Coast stations in her 47-year career. The Cross Rip station was discontinued in 1964, after 136 years of service. From then on, this intersection of sea-lanes would be marked by a lighted horn buoy.

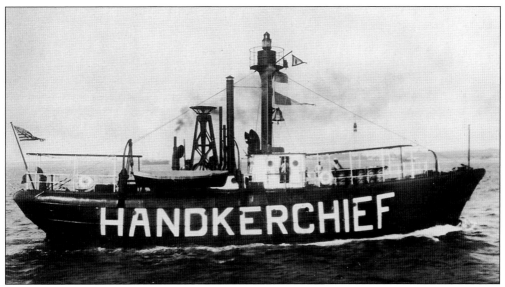

Pictured on Handkerchief Shoal Station, Light Vessel No. 98 (LV-98) was a steel-hulled "turtle back" type of light vessel. Frederick Thompson noted in *The Lightships of Cape Cod* that LV-98 became one of the favorite haunts for Coast Guardsmen, for on board was a cook named Gus who was reputed to serve the most delicious hot, twisted rolls in the service. In 1951, LV-98 was decommissioned after 21 years on station.

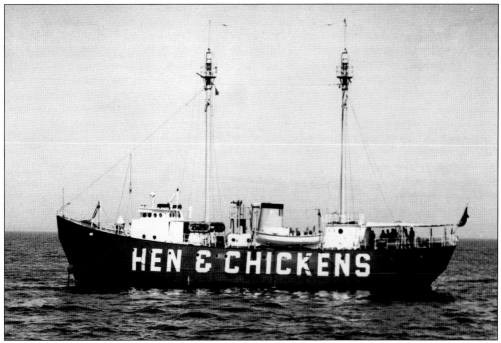

Hen & Chickens Light Vessel No. 86 is shown on station in March 1954. A short time later, this station was discontinued and replaced by the new Buzzards Bay Station, located four miles west of Cuttyhunk Light. Vessels guarding this station were blown adrift or dragged off station four times in severe weather. The former Vineyard and Hen & Chickens lightship stations would be replaced by a lighted buoy.

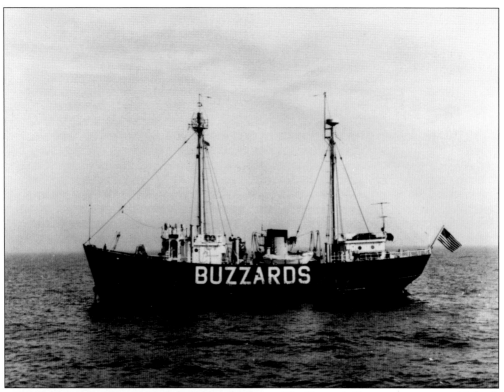

The Buzzards Bay station was established in 1954 to replace the Vineyard Sound and Hen & Chickens stations. Two vessels served on this station during its seven-year history—LV-86 and LV-110, shown here. LV-110 suffered severely at the hands of New England hurricanes while on this station. In 1954, one crewman was washed over the side. He was rescued by the Coast Guard the following day.

In 1961, the lightship was removed, and Buzzards Bay Entrance Light was constructed. The structure was known as a "Texas Tower" type and included a helicopter landing pad for use when maintaining the structure. With a water depth of 50 feet, this type of structure lent itself to this application. The structure lasted until 1996, when it was replaced by a smaller skeleton light tower.

A constant danger to light vessels was that of collision with passing ships. Since lightships were moored to mark obstructions within well-traveled sea-lanes or to function as "signposts" at approaches to ports, near misses and collisions in fog were relatively common. Here, the captain of LV-54 on the Boston Station inspects the damage after being rammed by the British steamer *Seven Seas Spray* on December 20, 1935.

Here, the lightship crew "gets their knees under the board" at the crucial "chow down." Lightship crews savored the hearty meals offered them at mealtimes. Like submariners, lightship sailors received the best meals available in appreciation of the hardships and dangers that they endured while moored on station. Lightships also received radios early in their development, and by the 1950s, they enjoyed shipboard television during their off time as well.

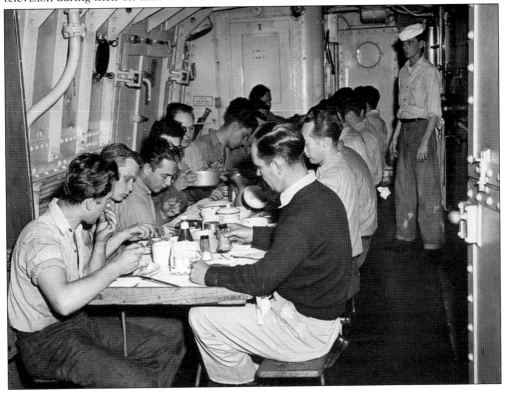

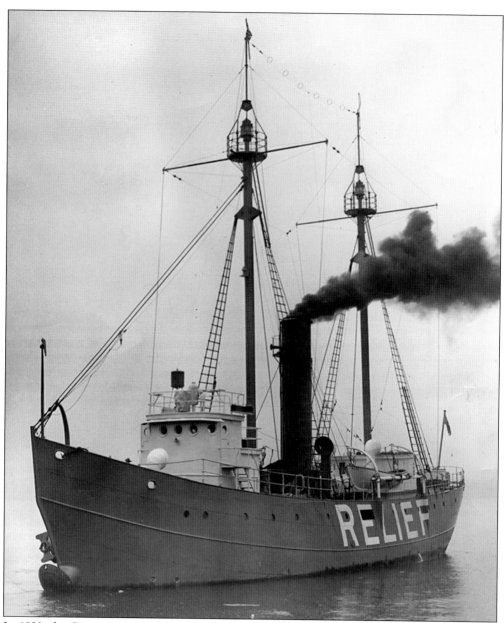

In 1939, the Coast Guard absorbed the Lighthouse Service. By the 1970s, the average tour of duty aboard a lightship was two years, with many men extending their duty. Shipboard life was vastly improved over the earliest days—ships were now designed with every possible safety feature, and comfort was not forgotten either. Living quarters were made roomier and were air-conditioned. Food was excellent, and a good cook was relieved of many of his standing watches by other crewmen as an incentive to retain him as chef. The men received liberty of one day of leave for every two or three days spent on station to compensate for the isolation and dangers endured. Every few weeks, as weather permitted, the tender would come alongside to replenish food and fuel and to pick up men going on leave and drop off those returning. Occasionally, when extensive repairs were needed, a relief lightship would serve as a replacement while the ship returned to port for repairs.

Eight

THE UPPER CAPE

The Upper Cape, consisting of the towns of Falmouth, Bourne, Sandwich, and Mashpee, is an area of handsome homes and has been proud and progressive over its long history. Like all Cape Cod communities, this area has had a long history of coastal trade, shipbuilding, whaling, glassworks, and salt making. In addition, the area drew much of its sustenance over the years from the land as well. Very early, the area too became an agricultural center for Cape Cod, including good meadow hay as a result of dikes to convert much of the salt marsh into meadow land.

Woods Hole, with its deep harbor, was distinguished in the 19th century as a whaling and shipbuilding area. These pursuits, coupled with the local offices of the US Bureau of Fisheries and the Marine Biological Station, required from the early years great attention to aids to navigation. To service the area, the US Lighthouse Service Depot was constructed in Woods Hole as well.

Besides the local maritime traffic, Nobska Point has guarded the outer area consisting of Nantucket Sound into Vineyard Sound and the stream of ship traffic passing Falmouth, the Elizabeth Islands, and Martha's Vineyard to the south.

The first lighthouse at Nobska (or Nobsque) was built in 1828 and, once again, was a typical Cape Cod–style structure with an octagonal lantern on top of the keeper's house, similar to that at Long Point and a number of other Cape Cod lights. There were three rooms on the first floor of the dwelling and two small rooms upstairs. The lantern held a lighting system of 10 lamps, each with 14-inch reflectors, displaying a fixed white light. Like similar lighthouses of the time, this one had problems with leaks, and the structure was racked during storms with the weight of the lantern on the roof. In time, a new lighthouse would be needed.

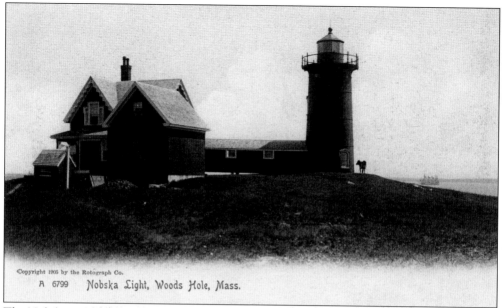

A 6799 Nobska Light, Woods Hole, Mass.

The Nobska station was a busy one. On one day alone in 1864, the keeper counted 188 vessels passing the station. The 40-foot cast-iron tower was installed in 1876 to replace the leaking and aging wooden light built in 1828. As with the cast-iron towers at Race Point, Eastham, and Chatham, the tower was erected in sections cast at the Lighthouse Depot in Chelsea and lined with brick.

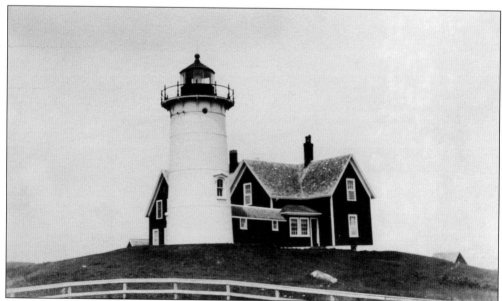

The Falmouth area suffers great periods of fog that required the keepers to spend countless hours striking the fog bell to warn vessels away. In the 1870s, a new weight-driven bell-striking mechanism was installed, and in 1888, the lens was upgraded to a fourth-order model with a red sector warning mariners of the dangerous Hedge Fence shoals. The iron tower was changed from red-brown to white in 1910.

Joseph G. Hindley Jr. was assistant keeper from about 1956 to 1968, when he became keeper. When he retired in 1973, Hindley was believed to be the last civilian lighthouse keeper in New England. His career in the Lighthouse Service dated back to 1927, when he was an assistant at Whale Rock Light. In 1985, the light was automated, and today, the station is the residence of Coast Guard group commander Woods Hole. Keeper Hindley is seen here with his wife, Charlotte.

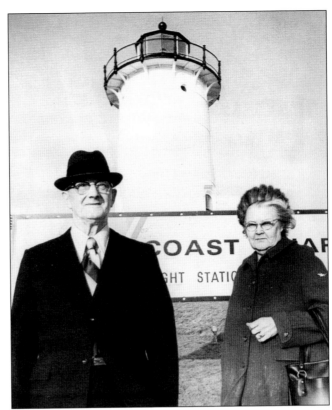

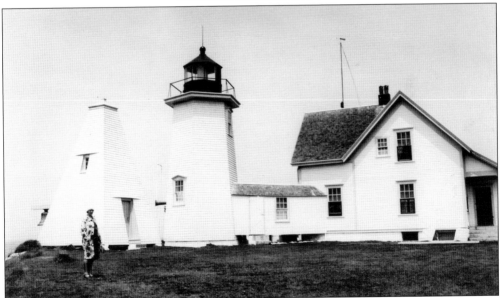

In the 1890s, the second lighthouse at Wings Neck in Pocasset was constructed to aid navigation on Buzzards Bay. The stately wood, pyramidal light tower connects to the dwelling by a wooden passageway. In 1922, the keeper's dwelling from the discontinued light station at Mattapoisett was brought across Buzzards Bay by barge to become the assistant keeper's house until 1946, when the property was sold.

The Cape Cod Canal Coast Guard Station consists of three Colonial Revival buildings: a station house, a boathouse, and a garage. The buildings were constructed as a support complex following the demolition of the original facility during the widening of the Cape Cod Canal in 1936. Today, Station Cape Cod Canal is responsible for securing the vital Cape Cod Canal, its approaches, and the treacherous waters of Buzzard Bay.

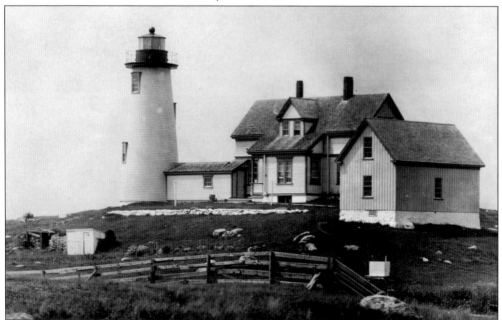

In 1602, when Gosnold landed from the bark *Concord*, Cuttyhunk became the site of the first English colonization. Although Cuttyhunk is relatively small, it lies in the well-traveled passage between Buzzards Bay and Vineyard Sound and thus required a reliable light. The third lighthouse at Cuttyhunk, consisting of a wooden tower connected to a six-room keeper's house, was constructed in the 1890s to replace the aging wooden 1860s light.

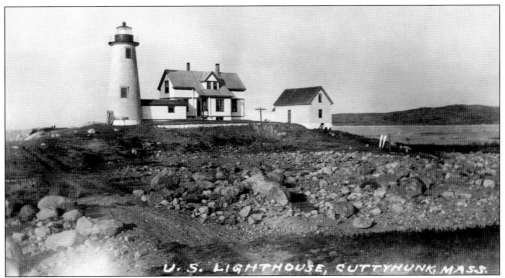

For years, the residents of Cuttyhunk had no running water and depended on rainwater for household use and drinking. There were springs on the island for some, but most had cisterns with a hand pump in the kitchen. All of the water had to be pumped for baths, washing dishes and clothing, and for other necessities. Bathrooms had a bowl and water pitcher, which would be filled from the pump.

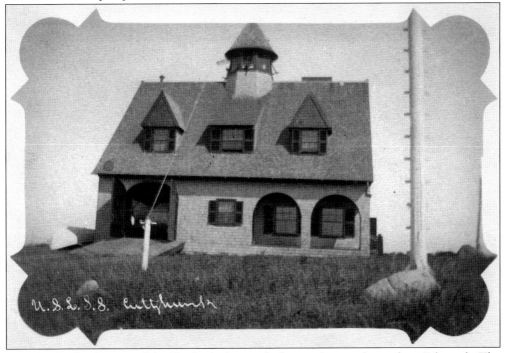

Cuttyhunk Island is one of the Elizabeth chain, which stretches southwest from Falmouth. The unusual 1889 life-saving station here was designed by Albert Bibb and was a one-of-a-kind shingle style. The octagonal watchtower and arched boat room doors combine to give the appearance of a cottage, and a most-attractive one at that. Shown here in 1907, the station stood near the east end of the island near Cannapitsit Channel.

On the Rocks. Aug 25, 1924 Cuttyhunk

In August 1924, while beating northward ahead of a gale, the bark *Wanderer* grounded on the rocks off Cuttyhunk. Fortunately, no lives were lost, but shipping and the towns along the coast were hard hit by the storm. In time, sailing vessels would become a memory as steam and diesel power took over. The station was manned by the Coast Guard in 1915 and remained open until the 1960s.

Cleveland Ledge lighthouse guards the southern approach to the Cape Cod Canal. The light was built on a concrete caisson and towed to the site in 1940. In 1944, the Coast Guard keepers on Cleveland Ledge would be severely tested as a dangerous hurricane swept north. As the waves increased, windows were shattered, and the water began to rise. However, the Coast Guardsmen persevered, and the light was never extinguished.

Nine

US Coast Guard

By 1913, as war in Europe loomed, Congress began considering consolidation measures both to save costs and to increase the efficiency of US Revenue Cutter Service and the US Life-Saving Service. The following year, World War I, "the war to end all wars," erupted in Europe. As the United States came closer to being drawn into the conflict, such consolidation measures became more vital.

On January 28, 1915, Pres. Woodrow Wilson signed a bill into law merging the US Revenue Cutter Service and the US Life-Saving Service into a new organization—the US Coast Guard. "With the flashing of wireless messages from every Government station along the Atlantic and Pacific Coasts . . . the United States Revenue Cutter Service and the Life-Saving Service ceased to exist, and men and vessels became a part of the United States Coast Guard Service."

Although the name and scope of the organization had changed, their duties remained the same. "From 1874 until 1915, only the highest standards of professionalism were exhibited by the life-saving crews. These standards have been carried forward by the US Coast Guard to today's crews, who still perform in keeping with the service's long history of dedication to the interest of mariners."

As the 20th century progressed and shipping transitioned from sail to steam, the life-saving crews had fewer and fewer wrecks to deal with. Improvements in ship design and navigational equipment, the advent of radio, radio-direction finding, and other developments reduced the need for many stations along the coast. In addition, budget constraints or partisan politics forced additional stations to close or to be merged together.

By this time too, a number of Humane Society stations had closed or been consolidated. However, their volunteer crews remained at the ready and still provided valuable assistance to the Life-Saving Service crews when needed. By 1916, only the Massachusetts Humane Society stations at Barnstable, Race Point, and Nashawena were still listed as active by the society. All were listed as having a lifeboat and, some, a Hunt gun with apparatus.

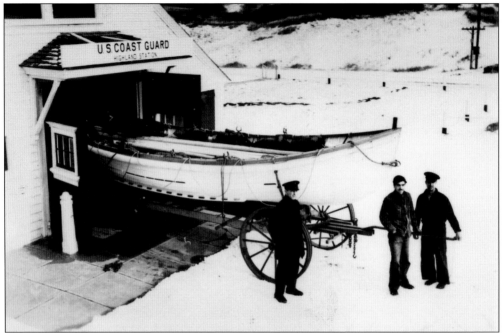

By the late 1920s, many of the Cape Cod life-saving stations had been outgrown or had fallen into disrepair after, in some cases, 60 years of use. Through the Works Progress Administration (WPA) and other Depression-era government programs, a number of stations on Cape Cod were replaced with a newer design. Shown is the Highland Station in the 1930s. Note the new paint scheme.

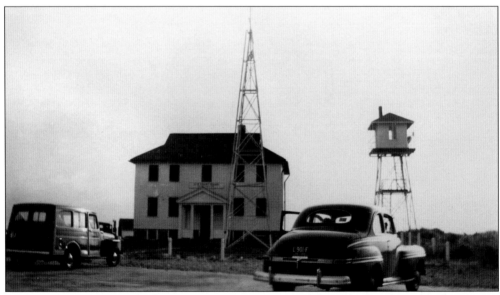

In these newer designs, the living quarters were separated from the boathouse and were now included in a two-story Chatham-type building. Stations of this type built in 1929 included Race Point, Highland, Pamet River, Orleans, and Chatham. As war dawned in the 1940s, the Cape Cod stations took on a renewed importance, with extra manpower for patrolling the area for U-boats and for spies put ashore.

In the early years, some life-saving stations had permission to keep or borrow draft animals to help pull their apparatus through the soft Cape Cod sand. At some stations, mules were used, but horses were preferred when available. By the 1930s, some Coast Guardsmen had the use of a Caterpillar tractor to tow the surfboat to the beach. After World War II, jeeps were used for this task.

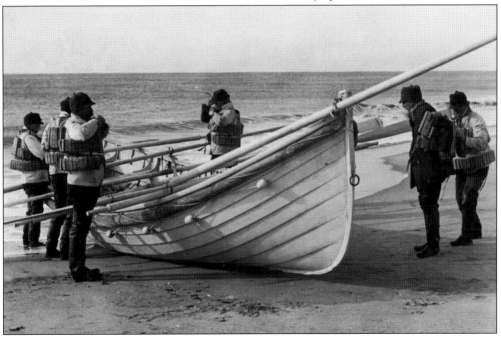

The standard boat used by the Life-Saving Service and early Coast Guard was the surfboat. Surfboats were lighter in weight, smaller, and of shallower draft than lifeboats. On Cape Cod, the standard surfboat for years was the 26-foot Monomoy type, manned by six surfmen rowing and the keeper at the steering oar. In 1899 alone, such surfboats along the US coastline made 1,089 rescue trips.

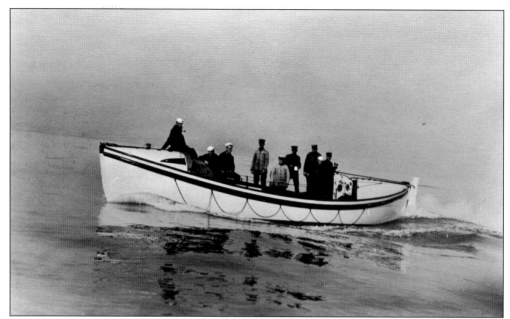

By 1910, the Life-Saving Service began converting to power surfboats and motor lifeboats. After the merger in 1915, the Coast Guard continued to improve the boats. More flotation chambers were added to keep the vessels afloat in a rollover, and the engines increased in power and reliability. Although surfboats were self-bailing, they were not self-righting. In time, a weighted keel would be added to right the motor lifeboat when capsized.

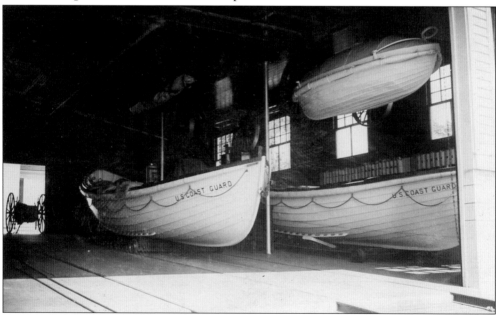

In extremely rough seas, when a line could be attached to a wreck, a metal life car might be used. Invented by Joseph Francis in 1838, the life car allowed two to four victims to enter and close the hatch. Much like the breeches buoy, the life car would then be pulled ashore with the victims aboard. Shown here hanging from the rafters, the life car was successfully used a number of times.

By the late 1920s, the Coast Guard was developing a new class of lifeboat—the T-class, 36-foot motor lifeboat. These boats were built by the Coast Guard at their Curtis Bay, Maryland, facility and featured a long, enclosed bow compartment for survivors, the helm amidships, and an enclosed engine compartment in the stern. This class became the workhorse of the Coast Guard until the 1980s.

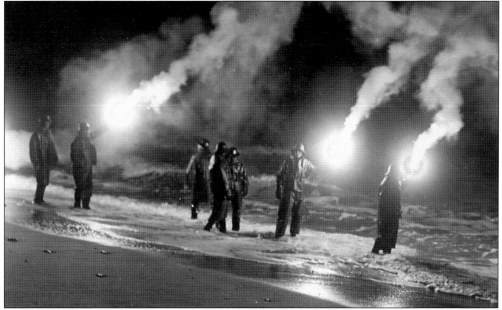

Patrol and rescue procedures continued to evolve as new equipment came into use, but the time-proven methods were still used. The fundamental means of discovering wrecks by patrolling the beach continued to pay dividends. Even in the worst weather, surfmen persisted and maintained continual patrols at night. If debris from a wreck was discovered, the red Coston flare was burned to alert the station and the sailors as well.

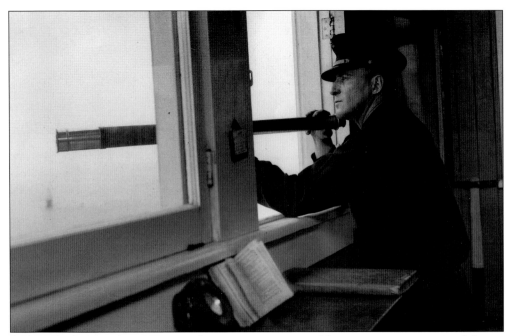

A sharp lookout in the station watchtower was maintained from sunrise to sunset and during storms. No chairs were kept in the tower, because it was thought that a man standing would be more alert than one sitting. Using his telescope, the lookout would scan to the limits of the station patrol area. Shown is BM1 Fritz Flukiger. He was killed when his surfboat capsized in 1938. (Courtesy Jeff Shook.)

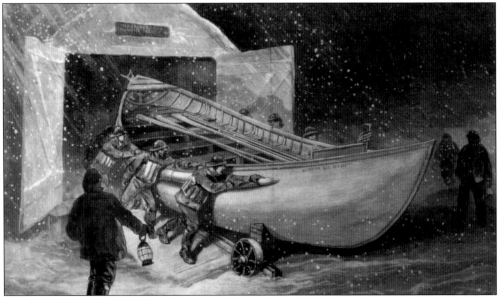

The last remaining active Massachusetts Humane Society station, located in Cohasset, was closed in 1936. Although the Massachusetts Humane Society no longer involves itself with life-saving efforts, the organization still exists today. Now it is focused on promoting life-saving efforts and procedures such as swimming lessons and CPR and in rewarding acts of heroism in the saving of life, presenting awards and medals to deserving persons.

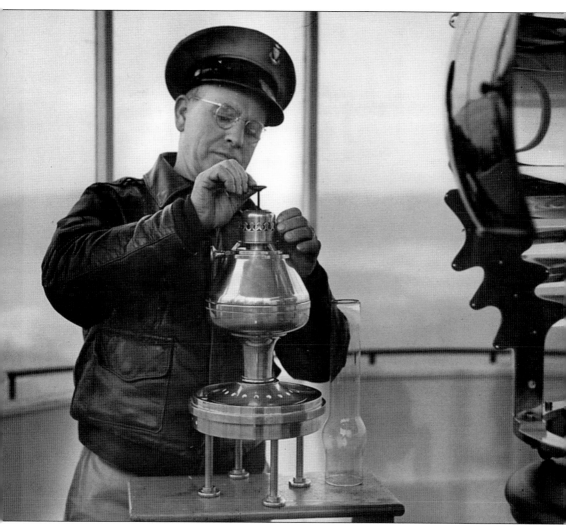

In 1939, the Lighthouse Service was abolished, and the responsibility for aids to navigation was placed under the Coast Guard. The many Lighthouse Service employees were given the opportunity to remain as civilian employees or accept a Coast Guard position. Lightships and tenders were transferred as well, with the personnel assuming appropriate rank. Station routine and responsibilities remained much the same, although uniforms and equipment saw changes. One of the most significant changes was the conversion from oil or gas to electricity. As power lines were extended in the 1930s and 1940s, more lighthouses were lit using this new technology. Telephone lines soon were extended along the coast as well, providing instant communication to summon aid. Today, some light stations have been discontinued, while others are automated, lit by street power or by solar. Only the country's oldest light station, Boston Light, still retains a keeper.

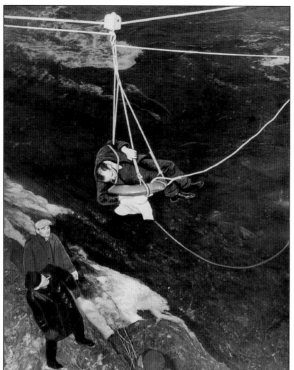

On November 6, 1921, the schooner *Leonora Silveira* went aground on Peaked Hill Bars off Provincetown. The Coast Guard quickly responded from the Provincetown stations and soon had a line to the vessel and the breeches buoy in operation. Seaman Edward Mose perished on the vessel, but Coast Guardsmen were able to rescue the remaining 17 crewmen in what was described as "thrilling work with the breeches buoy."

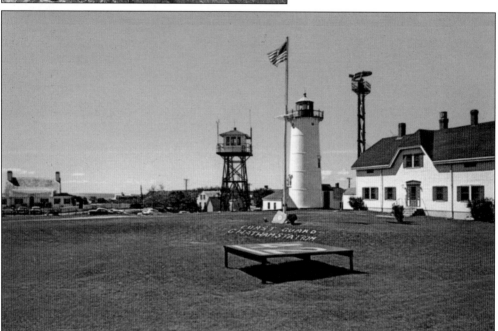

In the winter of 1952, New England was battered by the most brutal nor'easter in years. In the early hours of February 18, the men at Coast Guard Lifeboat Station Chatham manned the radios in anticipation of distress calls sure to come. Two tankers, the *Pendleton* and the *Fort Mercer,* built with low-quality steel, found themselves 10 to 20 miles offshore in the same horrifying predicament. (Photograph by Hayden Mason.)

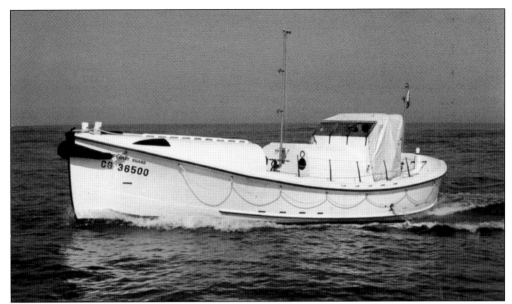

Soon, both tankers split in two, leaving the men on board utterly at the Atlantic's mercy. The men held out little hope, but the Coast Guard soon responded, dispatching cutters, and motor lifeboats CG-36383 and CG-36500 at Station Chatham made preparations to respond. These small but sturdy wooden boats were dwarfed by the enormous 60-foot seas and 70-knot winds, which far exceeded the conditions for which they were designed. (Photograph by William Quinn.)

By noon, BMC Donald Bangs and his crew of three left Stage Harbor in the CG-36383 and headed for the *Fort Mercer*'s last known position. BM1 Bernard Webber and his crew, EN3 Andrew Fitzgerald, SN Richard Livesey, and SN Irving Maske, also left in the CG-36500 powered only by its 90-horsepower gasoline engine. The men were aware that they were embarking on a possible suicide mission. (Photograph by Herbert Stier.)

As the CG-36500 approached Chatham's treacherous outer bar, she was smashed by mountainous waves and thrown high in the air. From Coast Guard accounts, the boat landed on its side, recovered, and was struck again. Tons of seawater crashed over the boat, breaking its windshield and compass and flattening coxswain Bernard Webber. Shown are survivors of the tanker *Fort Mercer* following their rescue as they arrive in Boston on the cutter *Acushnet*.

Webber struggled to regain control and steered into the towering waves to bring CG-36500 across the bar. Engineer Fitzgerald worked in the cramped compartment to keep the engine running as the weather and visibility worsened. Miraculously, the searchlight soon revealed a mass of twisted metal—the *Pendleton*, heaving high in the air with each massive wave. Shown are five survivors with Coast Guard chief warrant officer Daniel W. Cluff. (Photograph by Herbert Stier.)

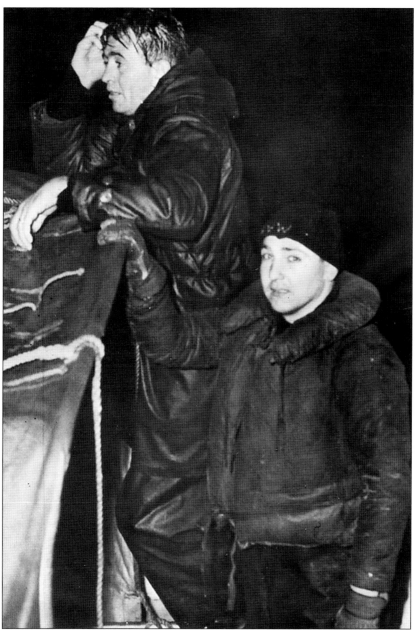

Soon, a ladder was lowered over the side, and, unbelievably, men clamored down. Coxswain Webber skillfully maneuvered the CG-36500. One by one, the survivors jumped on the tiny boat's bow or fell into the sea, where Webber's crew assisted them onboard. After multiple approaches and 20 survivors rescued, the CG-36500 began to handle sluggishly, but there was no turning back. It was all or nothing. So it went as the crew "stuffed" their human cargo aboard, risking their lives again and again. Finally, 32 of 33 survivors were onboard, and there remained only one giant of a man, George "Tiny" Myers, left on the *Pendleton*. But before the CG-36500 had maneuvered under the ladder, Myers jumped and was swallowed up by the sea. There was now nothing left to do but return—dangerously overloaded, lost, with no compass, and in zero visibility. Shown are BM1 Bernard Webber and Seaman Irving Maske on the CG-36500.

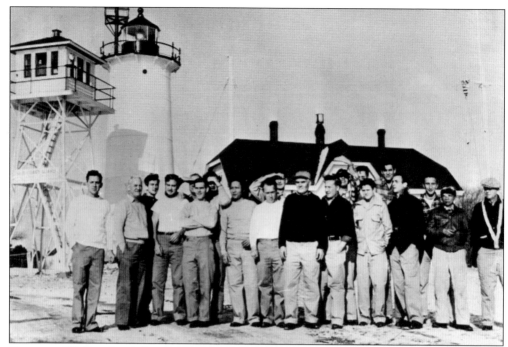

Coxswain Webber decided to put the wind and seas on the boat's stern and let them force the vessel ashore. In time, a red flashing light appeared. The boat's searchlight soon revealed the buoy that marked the entrance to Chatham and safe water. Although not all of the 84 men caught at sea that night survived, it is a testament to the Coast Guard crews that any came home at all.

To this day, the rescue of 32 men by the crew of the CG-36500 remains the greatest small-boat rescue in Coast Guard history. The rescue made international headlines, and for their heroism, the four stubborn Coast Guardsmen would receive the Congressional Gold Life-Saving Medal. In 1968, CG-36500 was retired. She languished in the bushes on Cape Cod for 13 years until being acquired by the Orleans Historical Society.

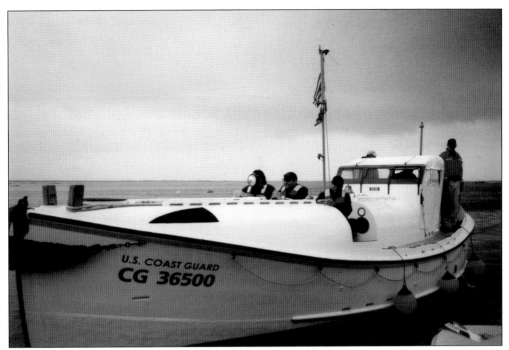

Today, CG-36500 has been lovingly restored by area volunteers and is again seaworthy. She is on exhibit as a floating museum dedicated to the memory of the lifesavers of Cape Cod. Being aboard her today as she still cruises near that dreaded Chatham Bar is a thrill indeed, bringing a heightened sense of respect for the Coast Guard crews that one will never forget.

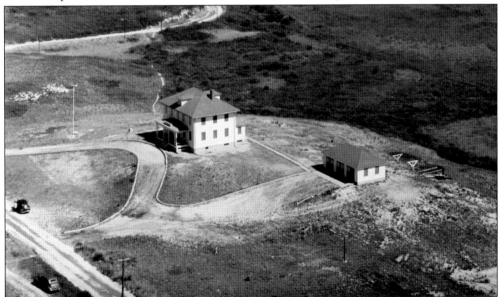

After World War II, some stations were closed as aids to navigation continued to improve and economics demanded. Although some Life-Saving Service and Coast Guard stations had been washed away or demolished over the years, others were moved or found new uses, including Race Point (now a national park ranger station), Pamet River (shown, now a youth hostel), Highland, Nauset, Old Harbor, and Chatham.

Still other Coast Guard stations have been consolidated from the 13 originals on the outer Cape. Today's Cape Cod stations include Air Station Cape Cod, Motor Life-Boat Station Chatham; Motor Life-Boat Station Provincetown; Sector Southeastern New England, Woods Hole; and Station Cape Cod Canal in Sandwich. Shown is the old Cahoons Hollow station, today a bustling beach restaurant and night spot.

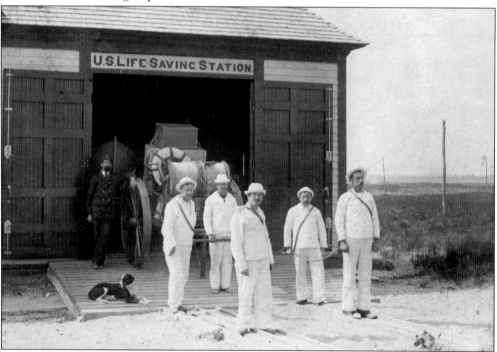

In Barnstable, the old US Customhouse today houses the Coast Guard Heritage Museum, dedicated to the preservation of the history of the US Coast Guard and its predecessor organizations. This outstanding museum preserves the history of these heroic lifesavers and helps the visitor to relive "the human drama of man's efforts against the relentless sea." Their wonderful displays are well worth seeing.

Bibliography

Claflin, James W. *Historic Nantucket Surfside Life-Saving Station.* Worcester, MA: Kenrick A. Claflin & Son, 2008.

Clark, Admont. *Lighthouses Of Cape Cod, Martha's Vineyard, Nantucket: Their History and Lore.* East Orleans, MA: Parnassus Imprints, 1992.

Dalton, J.W. *The Life Savers of Cape Cod.* Boston, MA: The Barta Press, 1902.

Driver, George Hibbert. *Cape-scapes.* Boston: Chapple Publishing Company, Ltd., 1930.

Edwards, Agnes. *Cape Cod: New and Old.* Boston: Houghton Mifflin Company, 1918.

Freeman, James. *A Description of the Eastern Coast of the County Of Barnstable, From Cape Cod, Or Race Point . . . To Cape Malebarre, Or The Sandy Point Of Chatham . . . Pointing Out The Spots On Which The Trustees Of The Humane Society Have Erected Huts, And Other Places Where Shipwrecked Seamen May Look For Shelter.* Boston: 1802.

Howe, M.A. DeWolfe. *The Humane Society of the Commonwealth of Massachusetts.* Boston: Riverside Press, 1918.

Kittredge, Henry C. *Cape Cod: Its People and Their History.* Boston: Houghton, Mifflin & Company, 1968.

Lincoln, Joseph C. *Cape Cod Ballads and Other Verse.* Trenton, NJ: Albert Brandt, 1902.

Shanks, Ralph and Wick York. *The U. S. Life-Saving Service - Heroes, Rescues and Architecture of the Early Coast Guard.* Petaluma, CA: Costano Books, 1996.

Snow, Edward Rowe. *Famous New England Lighthouses.* Boston: The Yankee Publishing Co., 1945.

Tarbell, Arthur W. *Cape Cod Ahoy!: A Travel Book for the Summer Visitor.* Boston: Little, Brown & Company, 1934.

Thompson, Frederic L. *The Lightships of Cape Cod.* Northborough, MA: Kenrick A. Claflin & Son, 1996.

Thoreau, Henry David. *Cape Cod.* Cambridge, MA. Houghton, Mifflin & Company, Riverside Press, 1894.

Webster, Capt. W. Russell, USCG. *The Pendleton Rescue.* Naval Institute Proceedings, December 2001. (Vol 127, pp. 66–69)

For further reading, the above original vintage titles and many others are available from Kenrick A. Claflin & Son Nautical Antiques—Since 1956 (www.LighthouseAntiques.net).

For additional information about lighthouses, life-saving, and Coast Guard stations, please contact the following organizations:

US Life-Saving Service Heritage Association (www.uslife-savingservice.org)
American Lighthouse Foundation (www.lighthousefoundation.org)
US Lighthouse Society (www.uslhs.org)

DISCOVER THOUSANDS OF LOCAL HISTORY BOOKS FEATURING MILLIONS OF VINTAGE IMAGES

Arcadia Publishing, the leading local history publisher in the United States, is committed to making history accessible and meaningful through publishing books that celebrate and preserve the heritage of America's people and places.

Find more books like this at
www.arcadiapublishing.com

Search for your hometown history, your old stomping grounds, and even your favorite sports team.